STRATFORD-UPON-AVON IN 50 BUILDINGS

ROBERT BEARMAN AND LINDSAY MACDONALD

AMBERLEY

First published 2022

Amberley Publishing, The Hill, Stroud
Gloucestershire GL5 4EP

www.amberley-books.com

British Library Cataloguing in Publication Data.
A catalogue record for this book is available from the British Library.

ISBN 978 1 4456 8830 5 (print)
ISBN 978 1 4456 8831 2 (ebook)

Typesetting by SJmagic DESIGN SERVICES, India.
Printed in Great Britain.

Contents

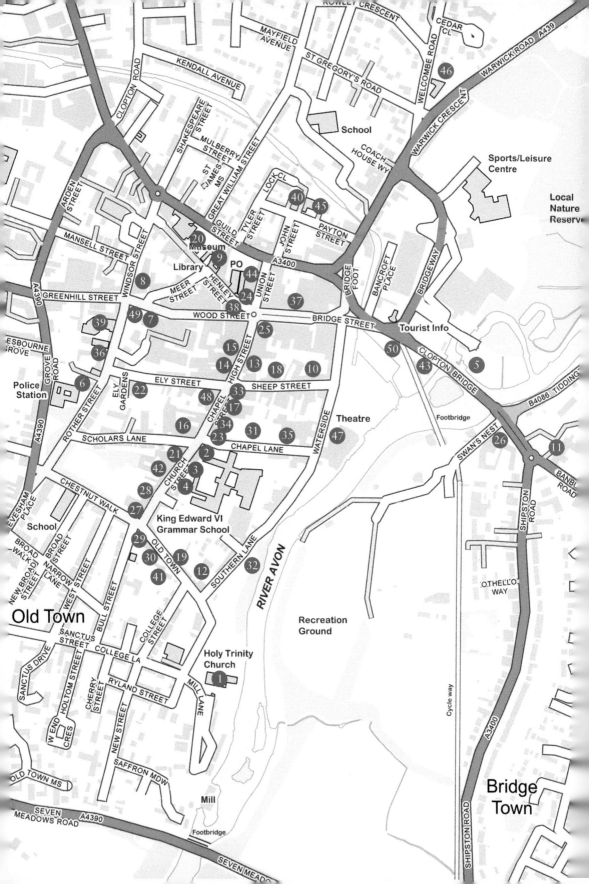

Key

Introduction

Stratford-upon-Avon owes its origin as a market town to a decision in the 1190s by the lord of the manor, at that time the bishop of Worcester, to lay out on open land what we would now call a planned town. This accounts for the grid pattern of the town centre streets still with us today. The existing settlement recorded in the Domesday Book (1086), a group of houses clustered round the parish church, was deliberately excluded from this new borough, explaining why Holy Trinity Church now lies so far from what became the centre of the new town. At the same time, the borough was granted a weekly market.

This new settlement developed steadily over the next 300 years, still officially subject to the authority of the lord of the manor. However, by 1400, a parallel body, the Guild of the Holy Cross, originating in a local religious guild founded in the borough's early years, had developed into an influential and richly endowed organisation. In its chapel, prayers were said for the safety of its members' souls after death and it also maintained a row of almshouses for its sick and elderly members, a school for young boys and a bridge over the river. Another religious foundation was the equally richly endowed College, from the 1330s housing a body of priests who served the parish church.

This all changed during the Reformation. Both the Guild and the College, as religious foundations, were suppressed in 1547 and all their property confiscated by the crown. The leading burgesses decided to follow the example of other towns and petitioned for the establishment of a legal body (a Corporation) able to own, manage and acquire property. In Stratford's case, this comprised much of what had belonged to the former Guild and College to provide an income to maintain the services for which those institutions had previously been responsible. For the next 500 years, it was this body that dominated the town's day-to-day life.

Most of the houses that until that time had lined the medieval streets were timber-framed, of one or two storeys and roofed with thatch. Some would have featured a central hall – open to the roof so that smoke could escape from a central hearth – flanked by two-storey wings (or in a simpler version by a single cross wing) for private use. The size of these houses had to conform to a width defined in the original charter (18 metres or 59 feet). At this early period larger houses of the gentry were sited beyond the original borough boundary.

The townscape changed dramatically at the turn of the sixteenth century as the result of three town fires, in 1594, 1595 and 1614. These destroyed many of the buildings in the town centre, taking out in all nearly 300 houses. The rebuilding

work that followed had dramatic implications for the appearance of the town. Many of the new buildings were three, instead of two, storeys high, each floor jettied out over the floor below, and topped by a gable – or multiple gables in the case of wider façades. The grandest of these, as one would expect, are to be found in High Street, the town's principal thoroughfare, with impressive ranges facing each other across the street at its south end.

The principal reason for the devastating effects of these fires was the building material, in particular thatch but also the timber framing. A fourth fire, in 1641, an outbreak of plague in 1645, and the disturbances of the Civil Wars also had a dampening effect on the town's economy and it was not until the Restoration of the monarchy in 1660 that the outward appearance of the town began to change again, with timber framing and thatch giving way to brick and tiles and with the design of buildings reflecting the increasingly popular classical style pioneered in London some fifty years earlier.

In the 1670s Sir John Clopton of nearby Clopton House had taken an interest in a project to make the River Avon navigable as far as Stratford and to develop a 'port' near Clopton Bridge. This never really got off the ground but two houses were built at the far end of the bridge. It was not only landed families that were involved in such developments. Some members of Stratford's town gentry had made their money in trade, others had prospered as lawyers. We find their new houses clustered together in Church Street and Old Town as if to make the point that their professional status obliged them to live in a part of the town not linked too closely to everyday 'shopping' activity. Further evidence of the town's prosperity during this period is the rebuilding in stone of the Town Hall. It was dedicated in 1769, as part of a three-day Shakespeare Jubilee organised by the famous actor David Garrick, an act of homage which set the town on its way to becoming a major tourist destination.

By the early nineteenth century many of the town's timber-framed buildings had been given a refronting of some sort, in an effort to make the town, so it was thought, look more modern and better maintained. In its simplest form, this merely involved applying a layer of plaster or stucco to the street elevation which, a century or so later, was removed when it was decided that a 'timber-framed look' was after all more in keeping with the town's growing fame as the place where William Shakespeare was born. However, many were left as they were after their first facelift, their internal timber framing concealed behind those later frontages.

The increasing pace of the Industrial Revolution had only a limited effect on Stratford's townscape, which instead continued to reflect its role as a market town well into the nineteenth century. However, the turnpiking of the county's roads in the eighteenth century to improve the flow of goods inevitably led to changes. As part of these improvements Clopton Bridge was widened in 1812 and a line of buildings down the centre of Bridge Street was demolished to ease traffic congestion. This led to the expansion of existing hostelry businesses, particularly the Red Horse, which was refronted in the latest style. Other premises were new-

built or refashioned in the same spirit, giving Bridge Street the Regency feel that it still enjoys today.

The River Avon had been navigable from the late seventeenth century and waterborne trade, particularly in coal, was given a significant boost with the completion of a canal in 1816 linking the town to Birmingham and the north. Ten years later, a horse-drawn tramway was constructed linking Stratford to Moreton-in-Marsh to the south, via a new bridge across the river. Both the canal and the tramway terminated at the Bancroft where one, later two, canal basins were dug. By the 1850s the area had been taken over by numerous wharves and warehouses, linked by a network of tram lines.

The population was also on the increase, leading to the first significant extensions of the town beyond the original borough boundary defined back in the 1190s. To the south, the demolition of the former College and the sale of its grounds in the 1820s led to the development of a network of streets lined with artisan cottages, nearly all of which still survive under the collective name of Old Town. To the north something grander was attempted: a development of villa-type residences in imitation of the spa towns, particularly nearby Leamington undergoing major development at that time. However, this new development, named New Town, failed to live up to expectations and as development spread westwards rows of smaller artisan cottages instead became the norm.

This increase in population led to the introduction of measures to tackle issues of public health, education and social welfare, reflected in some of the buildings that survive today. A sequence of buildings survive to remind us of the way in which a public health system evolved, from a public dispensary founded in Chapel Street to larger premises in Chapel Lane in 1837. In 1884 it reopened in Alcester Road, on the corner with Grove Road, as the town's first purpose-built hospital, on the site of the hotel that has since replaced it.

The religious needs of the growing number of Nonconformists in the town also had to be catered for. First in the field were the Independents (later known as Congregationalists), followed by the Methodists, active in the town from 1819. It is the Baptists, however, who today still use their first purpose-built chapel in Payton Street. It was also at this time that the Roman Catholics, after over 200 years of discrimination, were able to build a church of their own.

Towards the end of the century, there were some dramatic additions to the townscape in a style that has come to be known as 'high Victorian' or 'Gothic'. These buildings all have a Shakespearean association, reflecting the burgeoning interest in Stratford as a tourist destination, given an immense boost after the purchase of Shakespeare's Birthplace in 1847 as a national memorial and the site of New Place, Shakespeare's last home, in 1862. They include the Shakespeare Memorial Theatre, opened in 1879 (the remains of which, after a fire in 1926, are today incorporated into the Royal Shakespeare Theatre), the HSBC bank of 1883 in Chapel Street, with a terracotta frieze depicting scenes from Shakespeare's

plays, and the Memorial Fountain in Rother Street inscribed with quotations from the same source.

Few of Stratford's surviving twentieth-century buildings can be singled out as notable contributions to the town's architectural heritage. An exception would have been the Shakespeare Memorial Theatre rebuilt in 1932 to the designs of Elizabeth Scott but later alterations have not been kind to her original concept. More striking is the Shakespeare Centre in Henley Street, built in 1964 to commemorate the 400th anniversary of Shakespeare's birth.

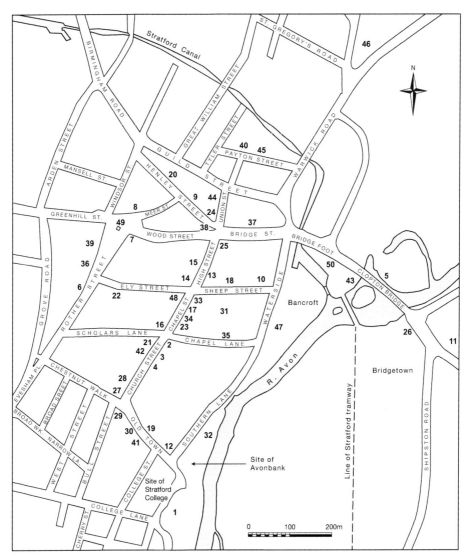

Most of the buildings described in this book are located around the medieval grid of streets laid out in 1196.

The 50 Buildings

1. The Parish Church of the Holy Trinity

Incorporated into the parish church of the Holy Trinity is the earliest building work in the town. At the time of the Domesday Book (1086), a priest was serving a small population of local villagers but of his church nothing survives. A hundred years later, the establishment of a new planned town led to a rapid increase in the population, reflected in the complete reconstruction of the church, with a chancel, nave and north and south transepts radiating out from a central tower in the form of a cross. There has been much rebuilding since, but the basic pattern survives.

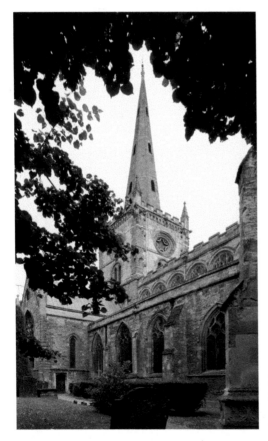

Holy Trinity Church, from the north-west, showing the ancient tower and a narrow lancet window of the thirteenth-century north transept.

Both transepts date from 1230 to 1250, their flat buttresses and narrow lancet windows clearly of that date. Intriguing features in the north transept also show that the original nave and chancel (since demolished) had narrow side aisles.

In the early fourteenth century the nave and its aisles were completely reconstructed in more or less their present form. This is clear from the style of the north and south arcades and of the more generously proportioned windows in the aisles. We also know, from a declaration in 1331 by locally born John de Stratford, then bishop of Winchester, that he had founded a chantry in the chapel of St Thomas in the south aisle, which he had recently rebuilt. This chantry was served by five priests, later to be housed in a college built on a nearby site. Other documents of 1313 and 1316 refer to the rebuilding of the Lady Chapel in the north aisle and another of 1325 to work on the tower, probably the reshaping of the four tower arches, very similar in style to the nave arcades.

The last major building phase took place at the end of the fifteenth century when the chancel was rebuilt, complete with its wonderful windows, at the instance of Thomas Balsall, Dean of the College, who in 1491 was buried in the tomb-chest ('of my ordaining', according to his will), which survives today in the sanctuary.

The nave, from the pulpit, showing the fourteenth-century north arcade and the late fifteenth-century clerestory and west window.

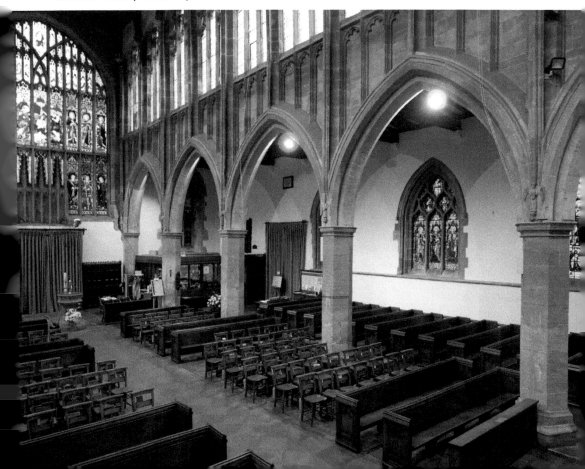

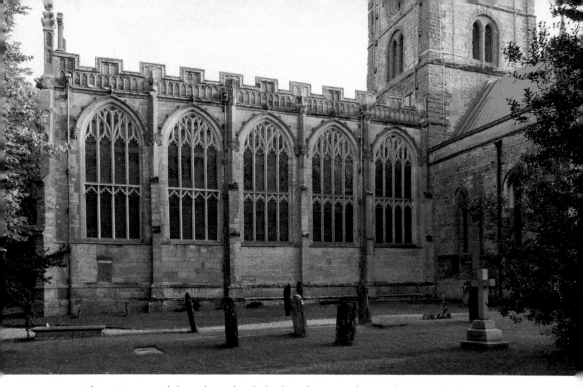

Above: Exterior of chancel, north side, built in the 1490s during Thomas Balsall's time as dean.

Below: The interior of the chancel. Thomas Balsall's elaborate tomb chest is to the north (left) of the altar. Above it, the nearer monument commemorates William Shakespeare. (Photo: Philip Welch)

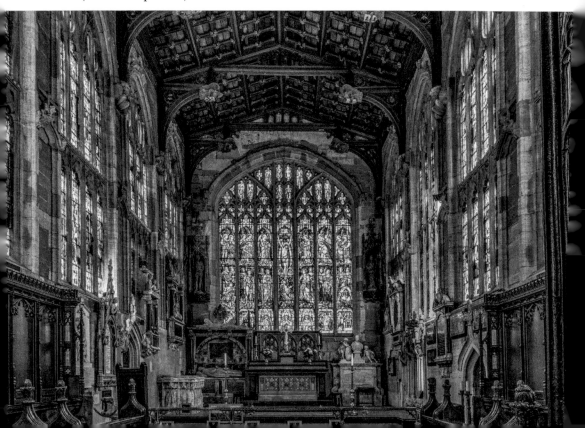

Of very similar date is the clerestory (two rows of twelve substantial windows facing one another) built above the nave arcades. At more or less the same time the west wall was rebuilt with its grand window and a new north porch added. The central tower, which had stood at its existing height since the late 1300s, was topped by the present spire in 1763.

Beautiful though the building is, it is also famous, of course, as the burial place of William Shakespeare, whose ledger stone and memorial in the chancel attract a steady stream of visitors.

2. The Chapel of the Guild of the Holy Cross

By 1269 there was a flourishing body in the town, the Guild of the Holy Cross, granted permission that year by the bishop of Worcester to establish in the town a chapel with hospital attached. Divine service was to be said in the chapel for the benefit of the souls of the departed faithful whilst the hospital was used to house the priests serving the chapel, the needy members (both male and female) of the Guild, and disadvantaged priests in the Worcester diocese in which Stratford then lay. Of the buildings erected for this purpose, on the corner of Church Street and Chapel Lane, very little survives but the rough stonework of the south wall of the

The Guild Chapel at dusk, with the Guildhall and almshouses stretching away down Church Street.

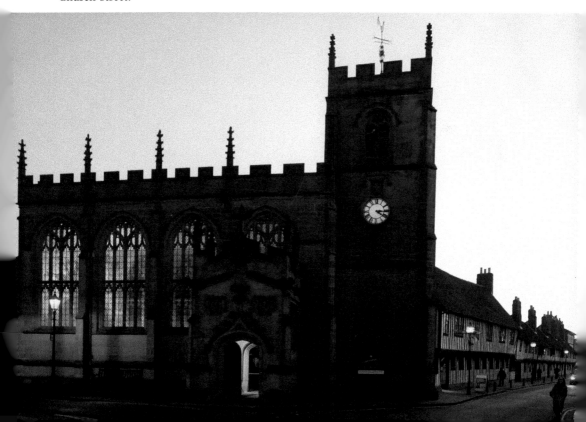

oratory (the chancel of the present building) may date back to that period. The hospital, on the site of the present nave, did not prosper and was soon taken over by the Guild for its meetings and social gatherings.

The next building phase dates from the mid-1450s when the chancel was rebuilt to take on its present form and the altar rededicated. Something far grander followed in the 1490s when the present nave, with its tower and porch, was rebuilt from the ground with money donated by locally born Hugh Clopton, who had prospered as a mercer in London, serving as Lord Mayor in 1492. The rebuilding work was in progress on his death and in his will Clopton mentions Thomas Dowland as the master mason involved in the project. The tracery of the huge windows is very similar to that in the chancel of the parish church (No. 1) dating from the same decade. Perhaps that too was Dowland's work.

The interior of the new building was lavishly adorned with wall paintings, including the Doom (or Day of Judgement) over the chancel arch, still clearly visible today. The murder of Thomas Becket and St George slaying the dragon were featured on the west wall, fragmentary remains of which are still there for us to see.

The Guild was dissolved in 1547 and in 1553 the chapel was given to the newly incorporated borough of Stratford. The wall paintings were whitewashed as the result of general government policy to do away with pre-Reformation imagery,

The Guild Chapel from the north-east. To the left is the modest oratory, rebuilt in the 1450s, with the grander nave, tower and porch built onto it in the 1490s.

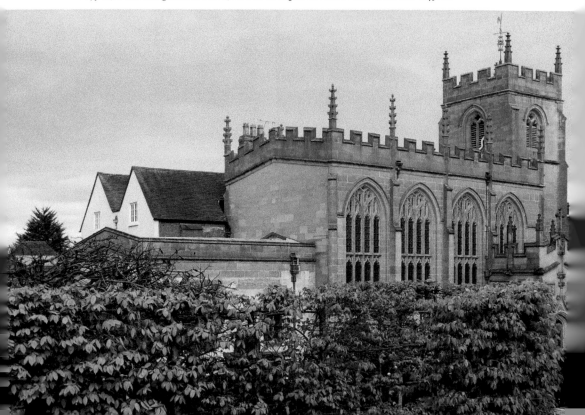

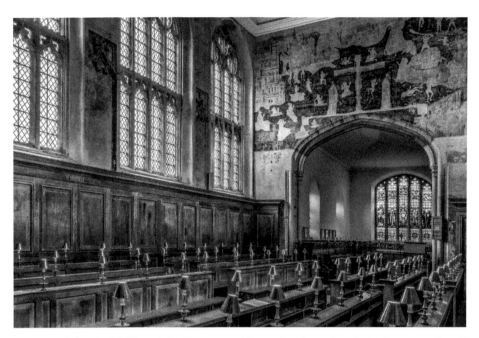

Interior of the Guild Chapel, looking east. Above the chancel arch is the restored wall painting of the Doom, or Day of Judgement. (Photo: Philip Welch)

and in the 1560s the chapel was fitted out simply as a preaching venue. The present seating and wall panelling were installed during a major restoration in the 1950s, followed in the 1960s by renewal of most of the exterior stonework.

3. The Guildhall and Grammar School

The Guild of the Holy Cross was refounded in 1403 when two smaller fraternities were merged with it. Then followed the most prosperous period in its history. It first provided itself with a purpose-built Guildhall, its account rolls for the year 1417/18 recording expenses for the necessary 'new building'. Recent dendrochronology (tree-ring dating) has confirmed that this relates to the fine two-storey timber-framed building adjoining the Guild Chapel. Its ground floor probably served as a 'great hall' where the Guild held its formal meetings and its annual feast, with, at the south end, a wall painting depicting the symbols and saints after whom the Guild was named. The floor above was made up of a smaller hall and a number of administrative chambers. The Guild, richly endowed and under the leadership of a master supported by a body of aldermen and two proctors, evolved into the town's quasi-governing body, which also took on the job of providing educational and charitable services. However, as in origin a religious foundation, it did not survive the Reformation and all its property, including the Guildhall, was forfeited to the crown.

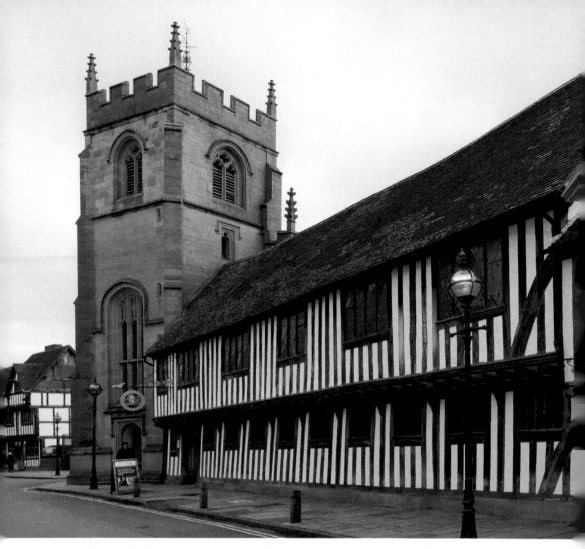

The Guildhall, built in 1417/18, and granted in 1553 to the Stratford Corporation. Its upper floor was taken over by the Grammar School in the 1560s.

The charter of 1553 created a new body, the Stratford-upon-Avon Corporation, under the direction of a bailiff and a body of aldermen and capital burgesses, to which was granted the premises formerly held by the Guild. This included the Guildhall itself, which, suitably adapted, became the Corporation's headquarters and where its meetings were held until 1864. The building was larger than was needed for routine business and in the 1560s, the school, until then conducted in an adjoining building (No. 4), was moved into the upper floor of the Guildhall. This is where William Shakespeare would have been educated. The ground floor remained under the direct control of the Corporation until 1864, when the Town Hall (No. 33) became its headquarters. Parts of the ground floor were then used for a variety of purposes (including accommodation for the town's fire engine) whilst other areas were taken over by the school. Following restoration in the 1890s, the whole of the ground floor was formally made over to the same use.

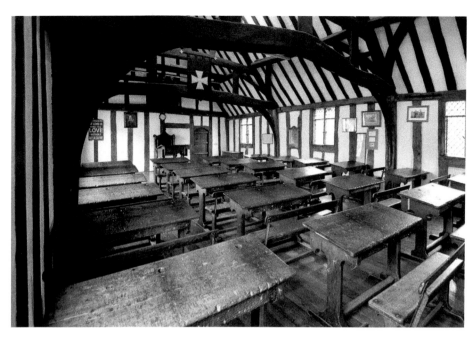

The upper floor of the Guildhall, still in use as a classroom by King Edward VI School ('Shakespeare's School').

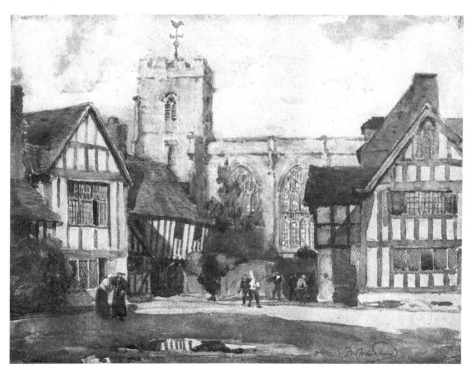

Watercolour by Frederick Whitehead of the courtyard of King Edward VI School, *c.* 1900, showing the Guildhall (left) and (to the right) the Pedagogue's House (see No. 4), with the Guild Chapel beyond.

4. The Old Schoolhouse and the Almshouses

The row of almshouses built by the Guild of the Holy Cross stretches along Church Street but the first building attached to the Guildhall has recently been identified, both by dendrochronology and an entry in the Guild's accounts, as a purpose-built schoolhouse, dating back to 1427/8. Schoolmasters are known to have been on the Guild's payroll since at least 1295 and in 1403 John 'Scolemaster' had been granted a chamber in the Guildhall in which to live. The schoolhouse, however, 'with room above,' was built specifically for the job. Under the town charter of 1553, its management was taken over by the Stratford Corporation and the school continued to the held there into the 1560s, before its transfer to the upper floor of the Guildhall (No. 3). At the same time the master was provided with new accommodation.

The row of almshouses is later, comprising sixteen units on two floors. As with the school, there had been earlier almshouses, or at least an almshouse, but these were replaced soon after 1502 by this new development, paid for out of a generous bequest to the Guild by Thomas Hannys. Like Hugh Clopton (see Nos 2 and 5), he was a native of the town but had prospered in London as a mercer. In his will of 1502 he left enough money to build this impressive new row. He even attached a plan (now lost) to show how these, together with a hall, parlour, buttery, kitchen and a little chapel or oratory, might be laid out.

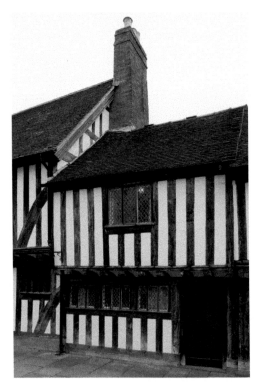

The original schoolhouse, built by the Guild of the Holy Cross in 1427/8, now sandwiched between the Guildhall and almshouses.

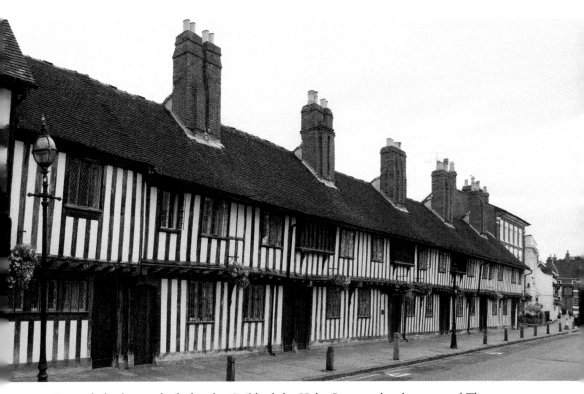

Row of almshouses built for the Guild of the Holy Cross under the terms of Thomas Hannys's will, *c.* 1503.

 This plan was not followed in all its details and a recent attempt to date the almshouses by dendrochronology produced only a date range of 1495–1520. However, work on buildings to the rear of the Guildhall (including the Pedagogue's House) came up with a date of 1503. Assuming, then, that these were the other buildings allowed for in Hannys's will, the case that the almshouses also date from the same period is more or less certain.

 As with the school, responsibility for the maintenance of the almshouses and the welfare of the almsfolk was transferred from the Guild to the Corporation under the charter of 1553.

5. Clopton Bridge

Clopton Bridge, built in stone around 1490, replaced a succession of earlier timber bridges, the first mentioned in 1235. This in turn was an improvement on the ford that had existed before the foundation of the new borough in the 1190s. The new stone bridge, of fourteen arches, was paid for, and later named after, native-born Hugh Clopton (see No. 2), who, as a successful businessman, recognised the value of good communications if Stratford were to thrive. Indeed, in his will of 1496 he

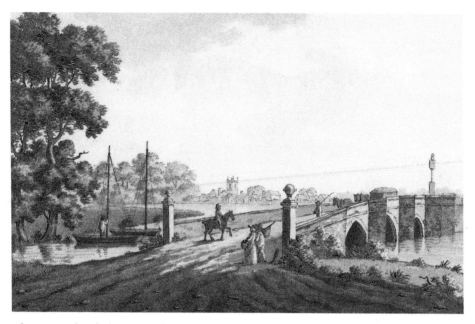

Clopton Bridge, before its widening in 1812, engraved from a drawing by Samuel Ireland and published in his *Picturesque Views on the Upper, or Warwickshire Avon*, 1795. The pillar at its midpoint (since lost) recorded that the bridge was built by Hugh Clopton (died 1496) 'at his own proper expence in the reign of King Henry the Seventh'.

left a further £50 for 'the repairing and amending of perilous bridges and ways within the space of 10 miles of Stratford upon Avon'. The work at Stratford also included a five-arched causeway on the town side to carry the road over the flood plain to the bottom of Bridge Street.

For some reason two arches had to be renewed in 1524 and both ends were damaged in a flood of 1588. During the Civil Wars an arch was also broken down by the Parliamentarians and not rebuilt until 1651. The parapets were raised to their present height in 1696.

The maintenance of this series of bridges was the responsibility of the bridge wardens, appointed by the Guild of the Holy Cross. The necessary funding was derived partly from small charges imposed on some houses in the town but this was supplemented by a more profitable annual festival known as the Bridge Ale, which included as a central feature, at least until the Reformation, the pageant of St George and the Dragon. After 1553, following the dissolution of the Guild, the Corporation reluctantly took over responsibility.

By an Act of Parliament of 1812 the bridge was vested in a body of commissioners charged with improving access to the town following the turnpiking of the roads and the subsequent increase in traffic. The bridge was widened on its upstream side (still clearly visible) and an attractive toll house added in 1814 at the town end. The iron walkway was installed in 1827, all part of improvements we will come back to when considering the present character of Bridge Street (No. 37).

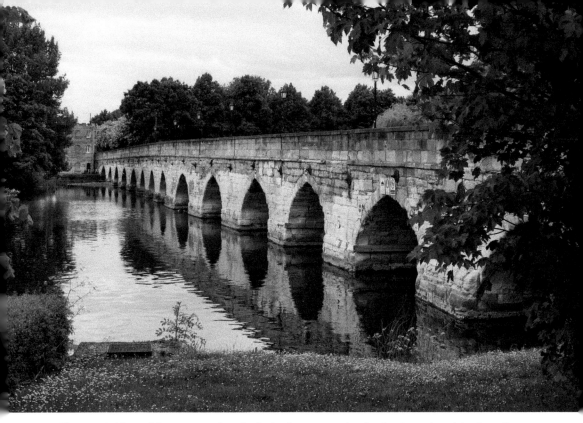

Clopton Bridge of fourteen arches, built in the 1490s. At the far (town) end is the toll house added in 1814.

6. Mason's Court, Rother Street

The buildings considered so far have been of an 'institutional' or 'public' type but there were, of course, many private dwellings lining the streets of the medieval town. Due to the four serious town fires of 1594, 1595, 1614 and 1641 (see Introduction), many of those which stood in the town centre were destroyed or seriously damaged. As a result, the best surviving examples of those medieval buildings are found today in streets that then were nearer the edge of town.

These early homes could take various forms and the best preserved in the town, Mason's Court in Rother Street, is of what is known as the 'Wealden' type. Typically this would have had a central hall, originally open to the roof to allow smoke to escape from a central hearth, flanked by two-storey wings, with jettied upper floors. The solar wing to the left was reserved for the family when they wanted some privacy, and the kitchen and service area was to the right. A passageway through the house would divide the hall from the service wing.

Mason's Court in Rother Street is easily recognisable as of this type, built in the 1480s by John Hodgkins. Following the introduction of chimneys to deal with smoke from the fire, a floor was often inserted into the central hall of these houses; and in this case, one of the jettied wings has also been underbuilt at a

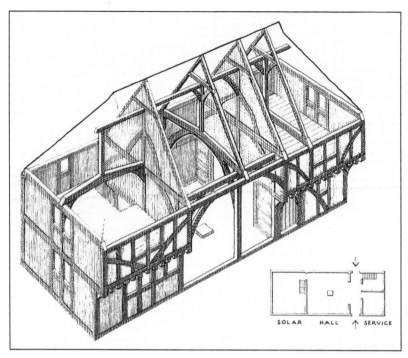

Above: Schematic layout of a medieval 'Wealden' house (drawing: Richard Harris, from his *Discovering Timber-Framed Buildings*, 1978).

Below: Mason's Court in Rother Street, built in the 1480s.

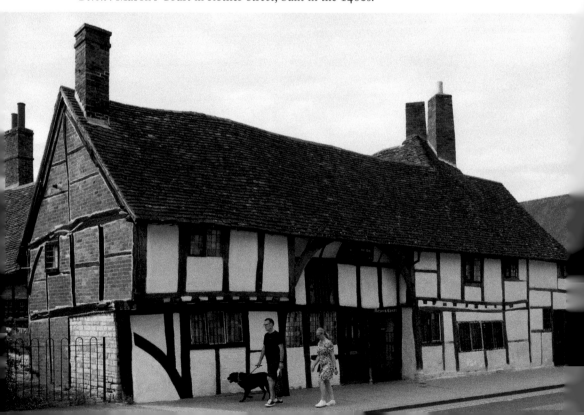

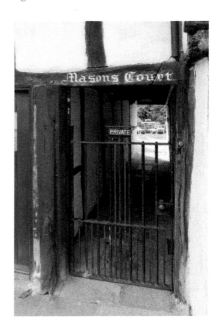

Central passageway through Mason's Court,
between the original hall and the service wing.
This would once have been closed at both ends.

later stage, but leaving the ends of the joists clearly visible. The building was also extended to the right by an extra bay, with wings to the rear added later. The original passageway, once closed at both ends, is now open, after the conversion of the building into separate units.

The plot ran back to what is now Grove Road, then the borough boundary, beyond which was open farmland. Indeed, for much of the sixteenth and seventeenth centuries, the building was occupied by yeoman farmers, including, from 1582 to 1625, John Gibbs, chosen as a member of the Corporation in 1584 and serving as bailiff on four occasions.

7. Parsons' House, Wood Street

There are other examples of this building type elsewhere in the town, hidden behind later refrontings. However, some are a little easier to examine. Nos 27–28 Wood Street, for example (Parsons' House, on the corner of Wood Street and Rother Street), may not be immediately recognisable. However, careful study of the Wood Street front reveals that the jetty between the first and second floors is divided into three sections, the left and right perhaps representing the jettied wings of a Wealden house. The central section, though now also jettied, is made up of less substantial timbers and may simply be evidence of a floor inserted into the former open hall after the introduction of chimneys.

This property belonged to the Guild of the Holy Cross, and later the Stratford Corporation, and the names of its occupants can be retrieved from early leases

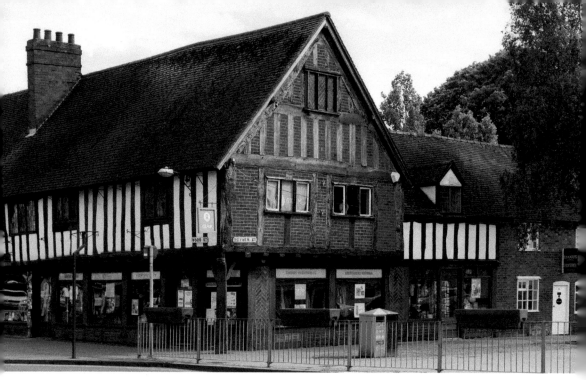

Above: Parsons' House on the corner of Wood Street and Rother Street, probably originally of 'Wealden' design, the home of William Parsons in Shakespeare's day.

Below: The original central recessed bay of Parsons' 'Wealden' house is indicated by the smaller joists (below the second window from the right), perhaps dating from the time that a floor was inserted into the former open hall.

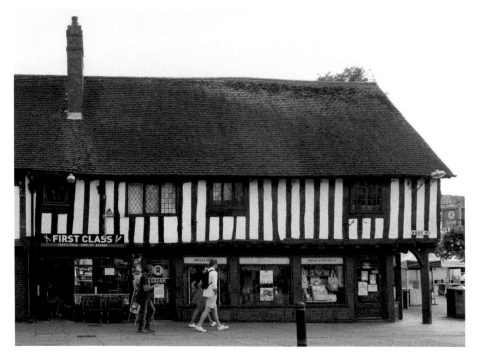

and rentals. In the early sixteenth century it was the home of Richard Roberts, an alderman of the Guild, followed from 1535 by Richard Brinklow, a smith. In Shakespeare's day it was lived in, from 1546, by John Page, an ironmonger, and then from 1580 by Alderman William Parsons, a well-to-do woollen draper, who served on the Corporation's governing body from 1580, holding the post of bailiff in 1590 and again in 1611. Fire damage in neighbouring properties appears to have blighted his fortunes. He had trouble over the renewal of his lease of the property in 1604, which was never resolved, and he only took on his second year as bailiff with great reluctance. After further difficulties in the Corporation's service, he moved to the Warwickshire village of Spernall in 1616, disqualifying himself from any further involvement, and died in September 1617. Of his children, John, born in 1581, matriculated at Balliol College, Oxford, in 1597.

8. White Swan, Rother Market

The White Swan in Rother Market could be another, albeit grander, version of a Wealden house. Its façade to the street is essentially a reconstruction of 1927, which brought forward the frontage by a yard or two but its overall appearance may still reflect what the building originally looked like. Internal evidence further confirms that it had a central hall open to the roof, flanked by two-storey jettied wings. In this instance, the wings are gabled, as they were in the earliest known

White Swan Hotel in Rother Market, refronted in 1927 but with an interesting interior.

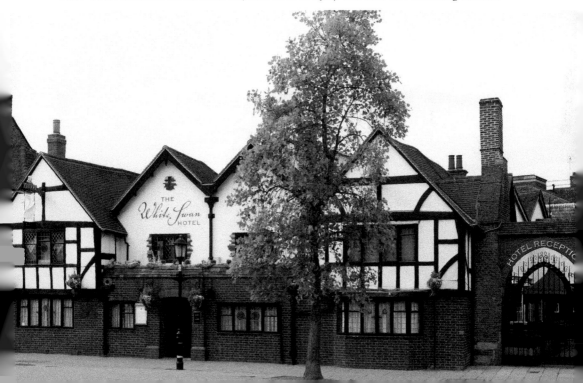

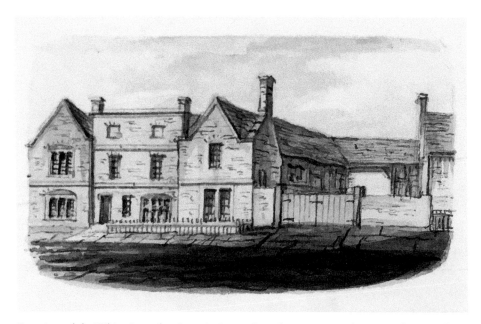

Drawing of the White Swan by Captain James Saunders, *c.* 1820, showing what may have been the former central hall bricked over. (By permission of Shakespeare Birthplace Trust)

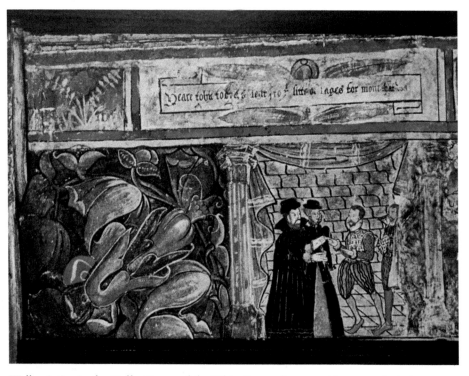

Wall painting in the Coffee Room of the White Swan, discovered in 1927, depicting scenes from the Book of Tobit.

drawing of *c.* 1820. This gives a good impression of the building as it looked then, albeit encased in brick and obscuring any jettying – and, indeed, the original appearance of the centre section.

 Inside the building more obvious evidence survives for an early date. The internal timbering includes clear indications of the original jettied wings, but the finest feature is the wonderful wall painting, discovered in 1927, depicting scenes from the apocryphal Book of Tobit. This may suggest that it dates from before the upheavals of the Reformation, when the Book of Tobit was relegated to the Apocrypha, but even so this did not make it an entirely forbidden subject. Moreover, on stylistic grounds, the work is not usually dated much earlier than mid-sixteenth century. At that time, or shortly afterwards, the building served as a tavern known as the Kings Hall or Kings House, held on lease by Robert Perrott and managed by his brother William. William, his wife Joan, and five of his children died during a plague epidemic of 1564.

9. Public Library, Henley Street

A variant design for the medieval house was the simpler arrangement of a hall, still open to the roof, but with a single two-storey cross wing attached to it. The only obvious example in the town is the building in Henley Street now serving as the

Public Library in Henley Street, originally a medieval house of hall and cross wing. The section to the right, faced in brick at ground-floor level, is an extension added in 1905.

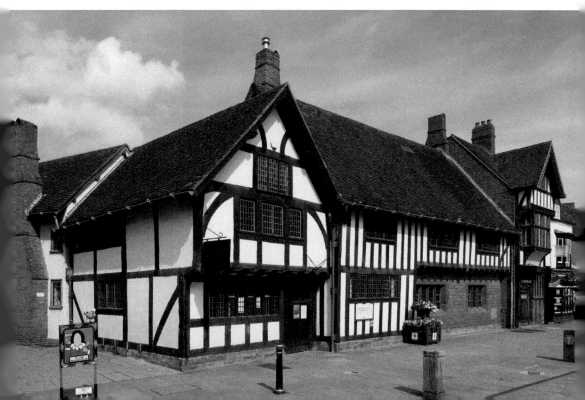

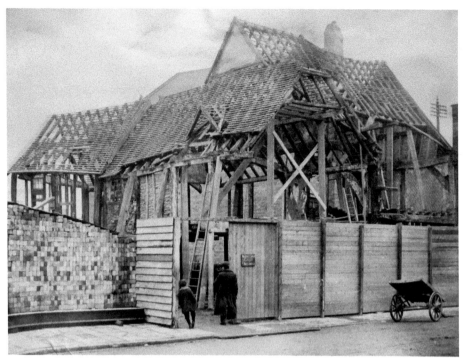

The future Public Library undergoing a rather too thorough restoration, *c.* 1903/4. (By permission of Shakespeare Birthplace Trust)

Public Library. From the street, it is clearly timber-framed even though much of the visible work dates from the early twentieth century when the building (until that point masked by a brick skin) was saved from demolition after a campaign led by the celebrated author Marie Corelli. Today we prefer restoration work to show some respect for the evidence of a building's evolution but this was not the fashion in 1904 and the ruthless stripping away of those later additions led to a virtual rebuilding of the external walls. Inside, however, there remains good evidence of the two-storey, jettied and gabled cross wing (to the left as one faces the building) that would have been reserved for private use, with a less obvious hall to its right. The bay even further to the right, as its foundation stone reveals, was a modern extension added in 1905.

Surviving rentals and leases document this property back to at least 1400 when it passed into the possession of the Guild of the Holy Cross. From 1526 it was tenanted by a succession of glovers and whittawers, William Fydkin from 1525, a proctor of the Guild and later a founder alderman named in Stratford's charter of incorporation (he died *c.* 1555), followed by Gilbert Bradley, sworn a capital burgess in 1565, and then William Wilson, who served as an alderman from 1581 (and bailiff in 1588/89) and died in 1605. During his tenancy the building was seriously damaged by one of the 1594/95 town fires, leading to extensive rebuilding work, mainly to outbuildings once running down from behind the house to what is now Guild Street.

10. No. 31 Sheep Street

Other buildings of this type are less easy to spot but a delightful, if smaller, example is to be found at the bottom of Sheep Street, believed by some to be the earliest surviving private residence in the town. The jaunty gabled cross wing, once jettied, has otherwise escaped over-restoration, and the original hall, albeit now floored over and partitioned, has also preserved much of its original timber frame. Information on its early history is very difficult to come by but it is doubtless typical of many of the smaller town houses once occupied by less well-off townspeople.

Other medieval 'hall and cross wing' houses may yet survive behind modern frontages but the only example so far examined in any detail is represented today by Nos 41–42 Henley Street. Behind its early nineteenth-century front wall, a richly timber-framed interior was discovered during restoration in 1983.

Medieval timber-framed house at the bottom of Sheep Street.

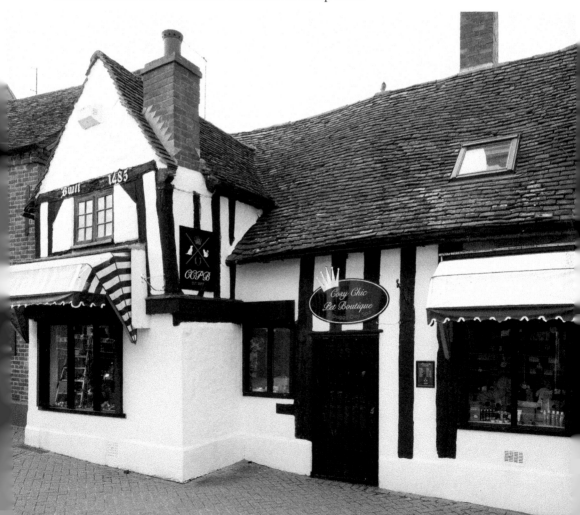

11. Alveston Manor Hotel

The buildings from this early period looked at so far were the homes of people living within the town centre, often involved in civic affairs and whose livelihoods were largely dependent on business dealings with fellow townsmen. For the houses of the gentry, with their income derived largely from land ownership, we have to move away from the town centre to sites where larger properties could be developed. One such, now the Alveston Manor Hotel, stood in the historic parish of Alveston, at the far end of Clopton Bridge but close enough to Stratford proper to be thought part of the town.

The present frontage of the building is made up of seven gabled bays. Four of them are Elizabethan or later but the late medieval house survives as the three central recessed bays. Its hall was in the central bay, with the original entrance in the ungabled section to its right. Further right was probably the service wing and, on the other side of the hall, the private quarters, both with gables over. In other words, this is essentially a larger version of, say, the White Swan in Rother Street (No. 8), its more generous proportions reflecting the status of its owners or tenants.

Before the Reformation, the manor of Alveston belonged to Worcester Priory. The original manor house was near the old church, over a mile from Stratford, so the function of what is now the Alveston Manor Hotel is obscure. At the

Front view of Alveston Manor Hotel. The three central bays set back represent the medieval house, with the flanking wings added later.

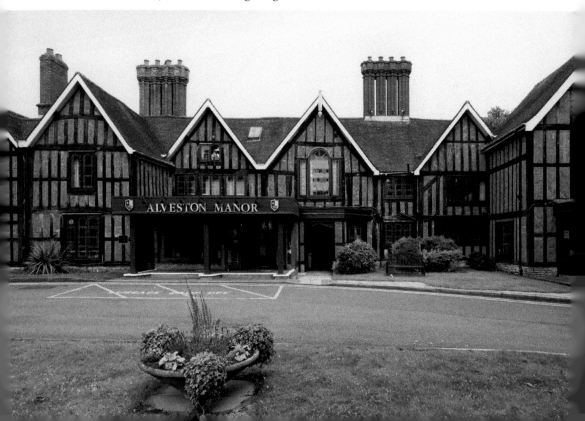

Reformation, the priory estates were taken into royal hands and then sold off. In 1603 the bulk of these, including what has now become the hotel, was sold to Richard Lane, who was already in residence. In fact, the family had been settled there for some time, and were probably responsible for some of those bays built onto the earlier house. Certainly Richard's father, the prosperous Nicholas Lane, whose fine monument (he died in 1595) survives in the old Alveston parish church, lived there and so, in all probability, had his father Richard. The second Richard, dubbed on his death in 1613 an 'esquire', was maintaining a household of twelve there in 1595. This was a step up in status from 'gentleman', and good evidence both that Lane's superior rank was generally recognised and that this had led him to put some distance between himself and those men engaged in trade, albeit wealthy, who were more closely involved in town affairs.

In the early eighteenth century a charming gazebo was built in the north-west corner of the gardens to overlook the roads leading in and out of the town over Clopton Bridge. Alterations to the road system have now left it isolated on a traffic island.

Early eighteenth-century gazebo once in the north-west corner of the gardens of Alveston Manor but now isolated on a traffic island after alterations to the road system.

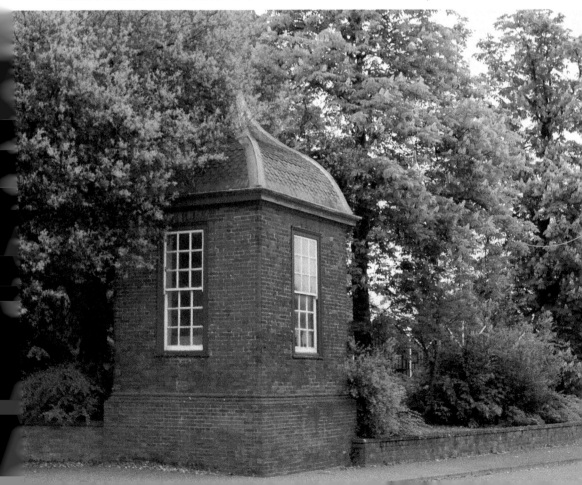

12. Dower House, Avoncroft and Old Town Croft

Also dating back to pre-Tudor times is the Dower House in Old Town, presenting to the street a long roughcast frontage, now divided into two separate houses: the Dower House, on the corner of Southern Lane, and Avoncroft running back along Old Town. However, much of what is now Avoncroft and a further detached building beyond, now Old Town Croft, are conversions into residential use of former outbuildings behind the Dower House, built to face Southern Lane. It is also from Southern Lane that some of its original timber frame can be most easily seen.

The site of the Dower House was outside the borough as then defined and so was not constrained by the size of the burgages laid out along the planned streets. The early history of the building is not clear but it almost certainly formed part of the property portfolio of the Stratford College, a body that from the 1330s had taken over the management of the parish church. The priests lived communally in a building since demolished, within a stone's throw of the Dower House. At the Reformation, the College was dissolved and its estates forfeited to the crown. These were later sold off in lots and one block, including both the College and the Dower House, was acquired around 1615 by the wealthy Combe family, who had been living in the College itself as tenants for some time.

The Dower House, also let out to tenants both before its purchase by William Combe, was probably occupied by the Reynolds family. Hugh Reynolds was holding extensive leasehold farms and farmland in and around Old Town on his death in 1556, and his son Thomas was maintaining a household of twenty-two in 1595. Both Hugh and Thomas were styled gentlemen, another good example of a propertied family establishing itself not in the town centre but on its fringe.

Dower House and Avoncroft, at heart a timber-framed medieval house now hidden behind roughcast cladding.

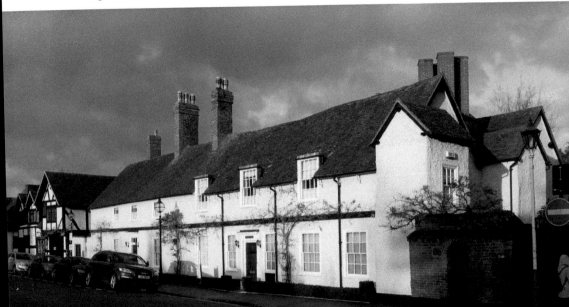

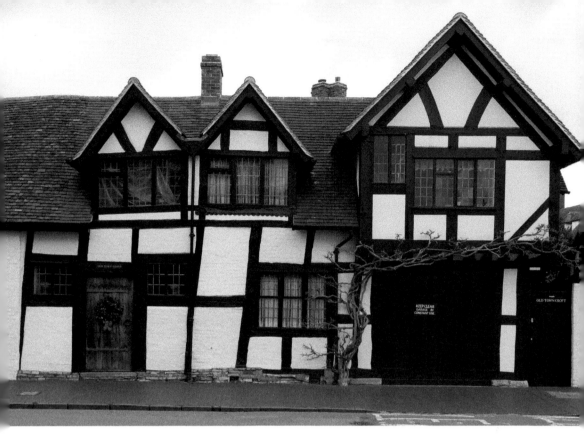

Old Town Croft: to the left, probably converted outbuildings once owned with the Dower House, and, to the right, a gabled 'mock-Tudor' addition of 1916.

The building is of complex plan but the original front, from Southern Lane, with its two gables and projecting porch, retains some of the original symmetry. Inside there is evidence of the former hall dating from the mid fifteenth century. Later, two wings, now largely filled in, were added to the main block, one of which now forms the frontage to Old Town. After William Combe's purchase of the freehold, the Reynolds family remained there as tenants, Thomas's son, William, receiving a token bequest in Shakespeare's will. It became known as the Dower House, after coming into the hands of the Clopton family at the end of the seventeenth century by a marriage into the Combe family.

13. Nos 17–21 High Street

We come now to the discontinuity caused by the town fires of 1594/95 and 1614, which destroyed many town centre houses, originally with their open halls (though some of these had been floored over) flanked by two-storey wings. The rebuilding after the fires produced a rash of buildings of a different type, the grandest of three storeys, each storey jettied out over the one below and the building topped with gables. For the façade to the street, close-set vertical studding on all floors

was the norm, sometimes embellished with decorative features of little structural importance but intended to reflect the status of the occupants.

High Street, where many of the town's well-established families lived, was particularly badly hit by the fires and this is where the best examples of these new buildings are to be found today. Nos 17–21, on the east side of High Street at its southern end, can be taken together as they all owed their reconstruction to the wealthy woollen draper William Walford. He had settled in the town in 1598 and three years later was chosen as a capital burgess to serve on the borough council. He was promoted to the rank of alderman early in 1609 and served as bailiff in 1610/11 and 1620/21. By the time of his death in 1624 he owned twenty freehold properties in the town together with an interest in several leasehold ones.

Nos 17–18 High Street, rebuilt by Alderman William Walford in 1614.

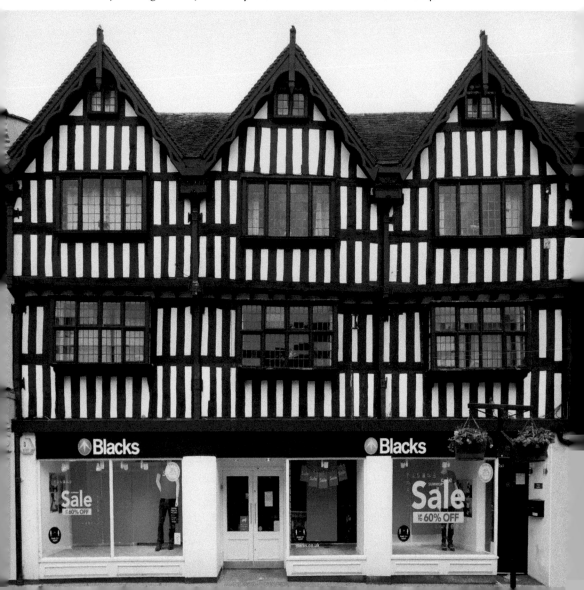

The three-gabled house at the north end of the row (Nos 17–18) was built on land owned by the Stratford Corporation. The earlier building on the site had been let in 1562 to George Whateley, who by his will of 1593 left the remainder of the term to his daughter Katherine, only thirteen at the time. She was still under age when the house was damaged in the 1594/95 fires but, after marrying Thomas Kirby, the Corporation granted the young couple a new lease on condition they rebuild the house within six years of her coming of age. Quite how thoroughly they did this is not clear but by 1609 William Walford had taken over the tenancy, and when he was granted a new lease in June 1614 he agreed to rebuild the house again. This is generally what we see today, complete with three jettied storeys each with its gable. Walford's will of 1624 confirms that this is where he lived.

Adjoining his house to the south was, on the face of it, an even grander building (now Nos 19–21), its timber frame clearly of one build, although two of its four gables are now missing. This was a freehold property in Walford's ownership and, from its appearance, clearly another post-fire house. However, in 1624, when he came to make his will, the building was described as already divided up into three units and let out. It is possible, then, that the whole unit was built with property speculation in mind.

Nos 19–21 High Street, once four-gabled, built following the 1594/95 fires.

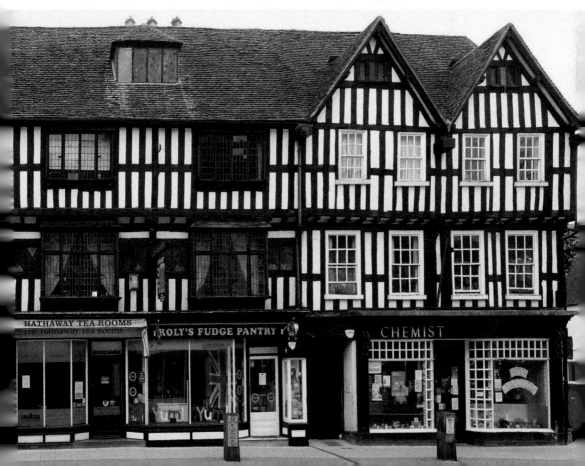

14. Harvard House, the Garrick Inn and Tudor House

Almost directly opposite is another fine range of post-fire houses, from right to left: Harvard House, the Garrick Inn, and what was earlier known as the Tudor House, the first two dating from 1595 to 1596 and the third clearly from around that time.

Harvard House was built by Thomas Rogers whose property extended into the house to the right (now plastered over), which may also have been built at the same time. His household in 1595 was said to include thirteen persons. We know he built it and when because his initials TR and AR (for Thomas Rogers and his wife Alice) are obligingly carved into the elaborate frontage together with the date, 1596, and, above, the further initials WR, taken to be William Rogers their son, born in 1578. The earliest views of the building (though there has been later restoration) show the same rich embellishments we see today, and so we can be sure – unlike many other timber-framed houses which were covered over at some point – that it has always presented this handsome frontage to the street.

Nos 23–26 High Street, including the Garrick Inn (centre) and Harvard House (right), both built in 1596.

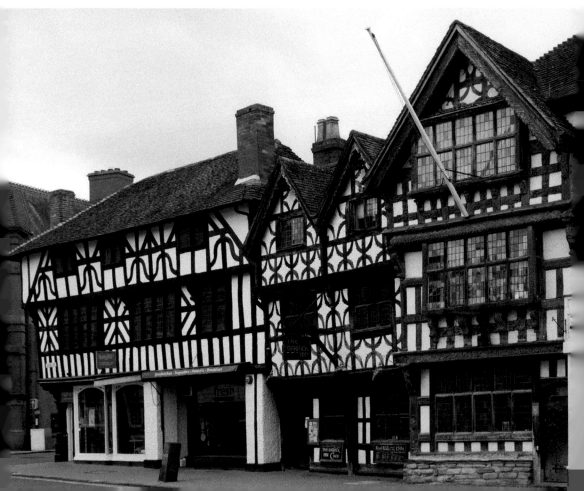

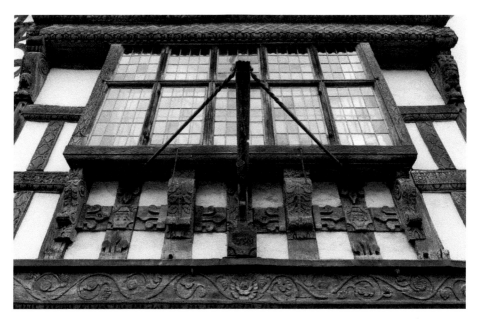

The initials of Alderman Thomas Rogers and his wife Alice carved into the woodwork of Harvard House together with the date 1596.

Thomas Rogers was chosen a capital burgess in 1585, and then swiftly promoted to alderman two years later. In 1589, he served as the town bailiff and was doing so again in 1595 when the first town fire broke out. His status and prosperity is clearly reflected, both in his civic career to date and in his rapid and speedy rebuilding of his house in this extravagant fashion. He was also forthright. In 1595, when enquiries were being made about the hoarding of grain at a time of disastrous harvest failure, it had been found that 'despite his butcher's trade ... he [Rogers] is a buyer and seller of corn for great sums' and 'hath in his house 15 quarters of malt and two of barley'. To this he replied 'that he careth not a turd for them all [i.e. his accusers]'. He resigned his membership of the Corporation on 21 April 1609 'by reason of his great age & his being grown unable through unfirmity to bear the office of Alderman'. He died in 1611. The building owes its name to the fact that Katherine, one of Thomas's daughters, married Robert Harvard, whose son John emigrated to America and founded what is now Harvard University.

The Garrick Inn next door, built on land belonging to the Stratford Corporation, also has an impressively carved façade though much of its frontage was reconstructed in 1912 using as a pattern a few remaining fragments. It was built after the fire by William, son of a wealthy mercer William Smith, perhaps with financial help from his father: by at least 1599, when the lease had been assigned to him, the property was described as 'a tenement new builded, tiled and a letting [i.e. a way out] via a tenement into Ely street'. By 1600 the building had passed to his brother, Roger Smith, yet another mercer, held by him until his death in 1626 when it was inherited by his son Francis.

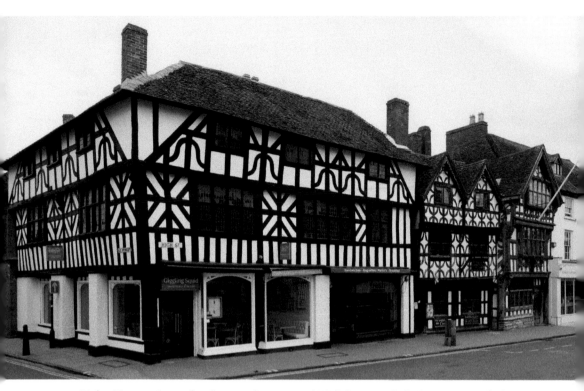

Tudor House, of post-fire date, on the corner of High Street and Ely Street. It was the home of John Woolmer by 1618.

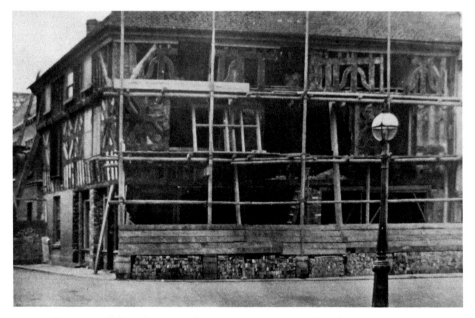

Removal in 1903 of the refronting of the Tudor House revealing the original timber frame. (By permission of Shakespeare Birthplace Trust)

The Tudor House next door is another good example of a three-storey and jettied post-fire house, though its gables have been lost in subsequent alterations. Of its documentary history, all we currently know is that by 1618 Alderman John Woolmer was in occupation, in 1595 described as the son-in-law of Thomas Rogers of Harvard House. His early career is obscure but he settled in Stratford in the late sixteenth century and was made a capital burgess in 1610, promoted to alderman in September 1614 and chosen to serve as bailiff in 1618/19. He prospered as an ironmonger and in 1650 died a wealthy man, leaving his house in High Street to his son, also John. It remained in the family into the 1720s. At some point the upper storey was remodelled, probably around this point (and certainly before 1800) when it was given a stucco facelift. When the stucco was removed in 1903 good evidence for the two large gables emerged.

15. No. 30 High Street

These imposing post-fire houses on both sides of the High Street were built by representatives of wealthy trading families who lived in this high-status street and who held important posts in local government service. Further along the street, on the west side, is another post-fire house with three jetties, though this time the twin gables have been later converted into a full second storey.

No. 30 High Street, a post-fire house with its two gables infilled later.

The status of the owner of this house is reflected in the finely carved bressumer beam supporting the upper jetty so it is no surprise to find that it, and the house to its right (now plastered over but richly timbered inside), belonged to the Quiney family, for four or five generations one of the town's leading families. Adrian Quiney, a mercer and an alderman since 1553, was three times bailiff, dying in 1607 well into his eighties. His son Richard predeceased his father but not before he too had been twice elected to serve as bailiff. He was the author of the only surviving letter to William Shakespeare, asking for his help in negotiating a loan. Richard's widow Elizabeth, an indomitable woman, was as equally long lived as her father-in-law, almost certainly making it into her nineties by the time of her death in 1632.

16. Falcon Hotel, Chapel Street

There are several similar buildings in the town centre, not as easily attributed directly to the town fires though clearly of the same sort of date. One of the most interesting is the Falcon Inn in Chapel Street. The documented history of the site cannot be pushed back much earlier than 17 May 1624 when it featured amongst

The Falcon Hotel on the corner of Chapel Street and Scholars Lane, built soon after 1622 by the Walford family and extensively restored in 2019. It was opened as an inn in the late 1650s.

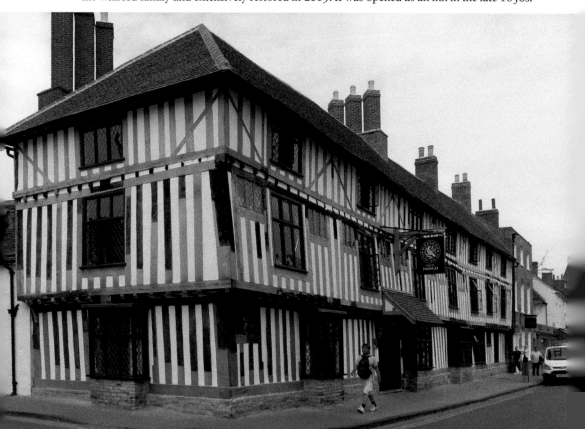

the properties included in the will of the wealthy Stratford woollen draper William Walford, whom we have already met as the tenant of Nos 17–18 High Street and owner of Nos 19–21 next door (No. 13). He left a further building in Chapel Street, on the site of the present hotel, to his youngest son, Francis Walford, described then as divided into two rented properties.

The timbers of the existing building have recently been dated to the period winter 1621/22 to spring 1622. Allowing for the fact that the timber may have been left for a year or so to season, it may have been Francis who rebuilt the inherited premises as a single structure. On the other hand, if the timber had been used soon after felling, it could still have been William's work, who true to form had rebuilt the premises by the time he made his will. Either way, it was still part of a substantial rebuilding programme in which the Walfords were involved and, like Nos 19–21 High Street, built partly as a speculation. Whether the fires of 1594/95 had played a part in this is not clear. Documentary evidence points to fire damage to a building on the site of No. 7 Chapel Street but not to No. 4 adjoining the Falcon.

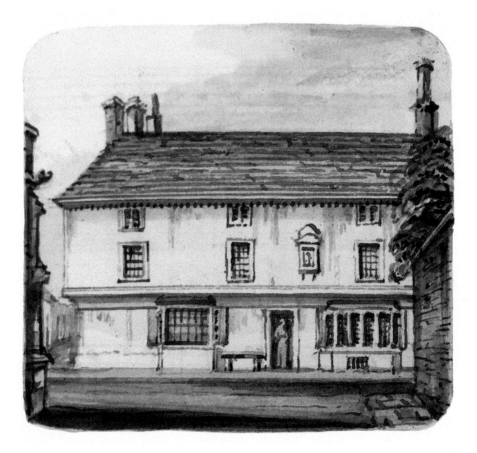

The Falcon Hotel, as it appeared after the building had been refronted. Drawing by Captain James Saunders, *c.* 1820. (By permission of Shakespeare Birthplace Trust)

The Falcon, which opened as an inn in the late 1650s – initially on the corner of Scholars Lane only – today lacks a jetty for the second storey and it was previously thought that this was because the upper floor had been added later. However, the recent dating of the timbers has established the same date throughout the building and a detailed architectural study has shown that the second storey was originally jettied but was later cut back flush with the first storey. This probably happened around 1800 when many of the town's timber-framed buildings were plastered over. Early drawings show that the Falcon underwent this treatment at about this time.

Careful restoration of 2018/19 required the renewal of much of the exterior timber framing, though internally considerably more of the original work has been preserved.

17. Shakespeare Hotel, Chapel Street

The Shakespeare Hotel, also in Chapel Street, could be another building from about this time but not quite as spectacular a structure as at might first appear. The building we see today, with its nine gables, was originally the site of three houses. The first two, next to the Town Hall, though genuinely timber-framed internally, were given a mock-Tudor façade, topped by four gables, in 1920 in honour of local people killed in the First World War. For its early history, documentary

Part of today's Shakespeare Hotel, originally two houses adjoining the Town Hall. They were given their four-gabled mock-Tudor façade in the 1920s but original timber framing survives internally.

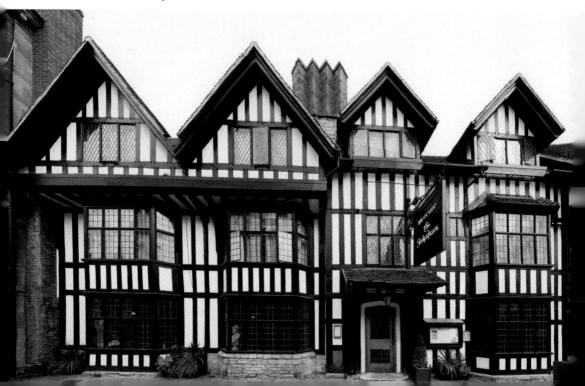

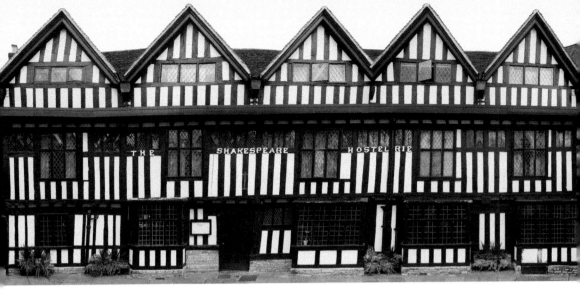

The five-gabled section of the Shakespeare Hotel, originally one-build of *c.* 1600. It was later divided into two houses.

evidence is difficult to come by. A house on at least part of the site was owned by Humfrey Reynolds on his death in 1556, when it passed to his son, recorded there in 1590. By 1637 it had passed to Thomas Taylor, an alderman from 1649 who was still its owner on his death in 1677, albeit divided into two parts; and it was in this part of the building that the Shakespeare Hotel, by at least the 1760s, was first established.

Next door stands the very impressive five-gabled double-jettied building, complete with carpenters' marks at first floor level to establish that it was one-build. However, despite appearances, it may have been built with the deliberate intention of dividing it into two sections for sub-letting. In fact even the ownership became divided between two freeholders in the eighteenth century. From 1637, and probably from the date he settled in Stratford, *c.* 1628, part at least was the home of John Loach, alias Richardson, a joiner, who died in possession in 1677. It was only by a piecemeal process, beginning in the 1880s, that it was absorbed into the Shakespeare Hotel.

18. Shrieve's House, Sheep Street

In Sheep Street, the misleadingly named Shrieve's House (William 'Sheryve', in 1542, was simply the building's first known tenant) is a different type of building from those we have looked at so far as it never had a jettied upper floor. Also of interest is its high arch to the right allowing the passage of loaded wagons to the outbuildings at the rear. These still survive as a fine row of what were once stabling and barns that must have characterised much of the back lands of the town centre but of which very few survive today. The documentary evidence is confusing but it was certainly a post-fire house. It belonged to the Corporation

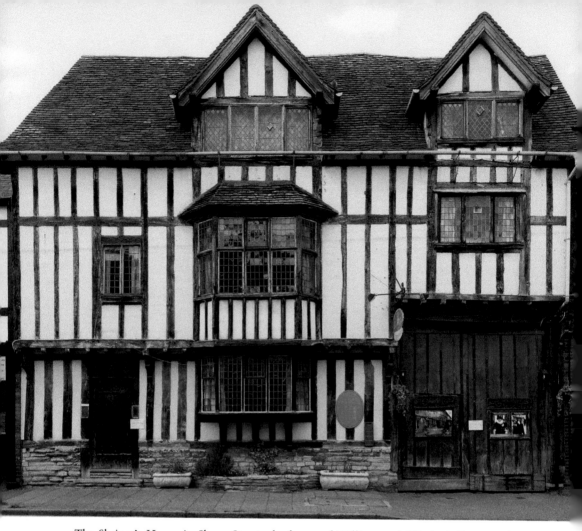

The Shrieve's House in Sheep Street, the home of William and Elizabeth Rogers when rebuilt in the early seventeenth century.

and was in the tenancy of William Rogers when the 1594/95 fires struck. He was a mercer by trade but also kept a tavern. Very shortly after the fires he was granted a lease subject to substantial building work after 'the most part of his tenement was consumed and clean burnt down to the ground'. This sounds clear enough but in fact the part that later surveys record as rebuilt seems to comprise a range of outbuildings – 'six bays of new buildings' recorded in a survey of 1599.

The fire of 1614, which affected many of the properties between Chapel Lane and Sheep Street, may have done further damage. By that time William Rogers was dead and it was his widow Elizabeth who had to face the cost of rebuilding. Under a new lease made to her in 1619 she was granted favourable terms in return for having 'newly builded the said tenement it being lately consumed by fire and covered the same with tiles'. At the same time, though, she was required to carry out further work 'at her own expense and charges [to] build upon all the forefront next adjoining the said premises good and substantial and sufficient

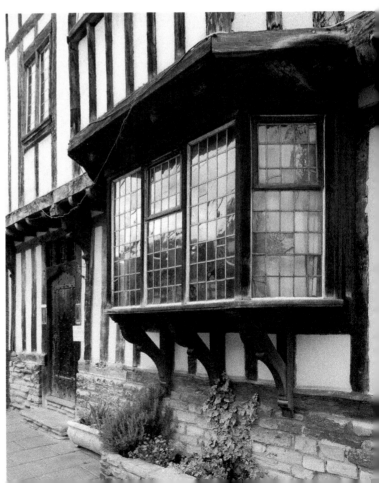

Above: A fine range of outbuildings at the rear of the Shrieve's House, the best of the few remaining examples in the town.

Right: The bay window of the Shrieve's House with leaded glass. It was probably an original feature but early views show it resting on a stone plinth.

building'. This sounds contradictory but we do know that Elizabeth put in a high claim (£80) for damage after the 1614 fire. Perhaps by the time she secured a new lease on the property there was confusion over quite what had occurred. In any event there can be no doubt that the building as we know it today, whether or not affected once or twice by fire, dates from the early seventeenth century.

19. Hall's Croft, Old Town

Not all buildings of this date were of quite the same type and instead could consist simply of ground and first floor, with attics above. Also the use of close-set studding was often confined to the ground floor, with open panelling used for the upper floor and gables (if they had them). Stratford's best example is Hall's Croft, in Old Town, now a rambling timber-framed building. At its core is a range dating from 1613 to 1614 below two large gables, with close-set studding at ground floor level but open panelling above. It was enlarged later in the seventeenth century, first with a free-standing kitchen in 1631, joined some twenty years later to the main building by the present hall, staircase and landing. Finally, at the turn of the century the bay with the smaller gable was either added or, more likely, remodelled.

Hall's Croft in Old Town, believed to be the home of Shakespeare's elder daughter Susanna after her marriage to John Hall in 1607.

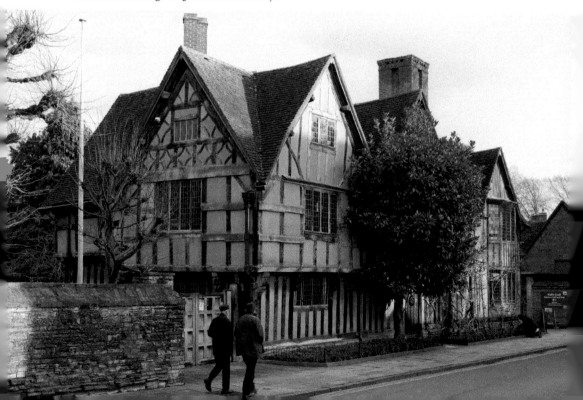

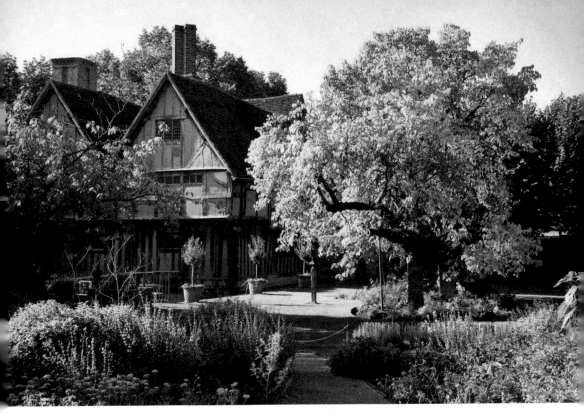

Rear view of Hall's Croft from the large enclosed garden.

Hall's Croft is believed to have been the home of Shakespeare's daughter, Susanna, after her marriage to Dr John Hall, the well-known physician. Subsequently it was the home of a succession of town gentry, though in the mid-nineteenth century it flourished as a boys' preparatory school known as Cambridge House. Later it operated as a girls' boarding school before reverting to domestic use in 1883. It was acquired by the Shakespeare Birthplace Trust in 1949.

20. Shakespeare's Birthplace, Henley Street

Shakespeare's Birthplace in Henley Street, when compared with the great three-storey jettied houses built by the town's leading townsfolk in High Street, is less imposing. It is of two storeys only, with close-set studding on the ground floor but, as with Hall's Croft, open panelling above. It is made up of a main three-bay structure of a single build to which was added a single bay to the street frontage (on the left when viewed from the street) and a rear extension of about the same date. The freehold belonged to John Shakespeare, father of William Shakespeare, at one time a leading member of the Corporation and bailiff in 1573/74. Ownership passed to William Shakespeare on his father's death in 1601, although it is possible that the whole family had by then moved to the much grander New

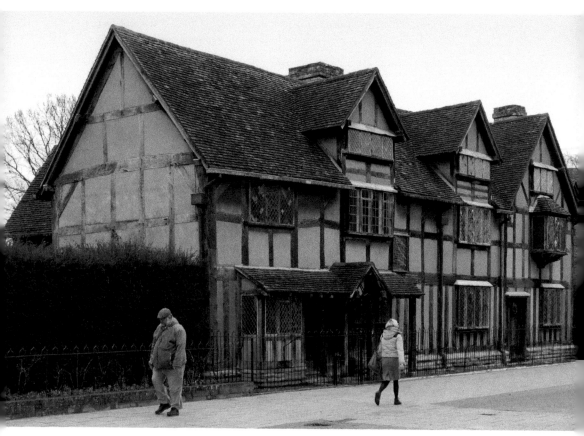

Shakespeare's Birthplace in Henley Street, substantially restored in the mid-nineteenth century.

Place in Chapel Street, which Shakespeare had purchased in 1597 (No. 31). The bulk of the property in Henley Street was then let to Lewis Hiccocks, who was still recorded there when he died in 1627, holding his share of the building under a lease which Shakespeare had granted him. By his will of 1616, Shakespeare granted the occupancy of the smaller part of the premises to his sister Joan Hart for life, and by some later arrangement her descendants continued to live there after her death.

Hiccocks, a yeoman, was also a victualler and opened a tavern or inn in the property he rented, known initially as the Maidenhead, later the Swan and Maidenhead. It continued in that use into the nineteenth century, although part was later converted into a butcher's shop. The ownership of both the inn and the Hart residence remained with Shakespeare's direct descendants until the death of his granddaughter Elizabeth Barnard in 1670 when the freehold of the whole property was given to Thomas Hart, Joan's grandson, whose descendants remained owners until 1806. By the mid-eighteenth century a growing interest in Shakespeare's life story had led to the identification of the house as his birthplace

and childhood home. This led initially to a trickle of visitors, then a stream, and from 1847 more like a flood, after the house was purchased and restored as a memorial to the poet.

On its purchase, the ownership of the house was placed in the hands of a body of trustees, confirmed by a private Act of Parliament of 1891. In 1964, to commemorate the 400th anniversary of Shakespeare's birth, the trust sponsored the building of the Shakespeare Centre next door. This was designed by Lawrence Williams, remarkable not only for its modern design, in brick, granite and concrete, but also for its numerous bronze and aluminium window openings on the garden front – and to the bold decision that a building of such an adventurous design could be built, in the words of Nikolaus Pevsner, 'in such a hallowed spot'. Its elevation to the street is embellished with commissioned artwork by Douglas Wain Hobson and, more importantly, a series of large glass panels engraved by John Hutton with Shakespeare characters gracing the approach to the original entrance.

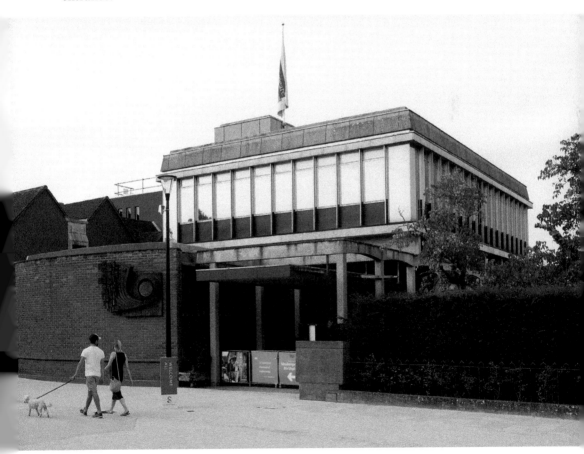

The Shakespeare Centre built adjacent to Shakespeare's Birthplace in 1964 to serve as the library, archives and administrative headquarters of the Trust.

21. Town House, Church Street

The refronting of some of the town's ancient properties (and sometimes their later restoration) has been mentioned several times. At the turn of the twentieth century the only house in High Street with its timber frame still exposed was Harvard House, the remainder stuccoed or plastered over. In cases where such covering was simply removed, the work, by the standards of the time, was honestly done, revealing the original frame more or less intact (e.g. Nos 3, 13–14). On other occasions the first 'improvers' had chosen to demolish and rebuild the front wall entirely in their chosen style. The best example is the Town House in Church Street, on the corner of Scholars Lane, which underwent not just one face-lift but two.

At heart, the Town House is a substantial timber-framed building probably dating back to the late sixteenth century, as its gable facing Scholars Lane shows. For a hundred years it belonged to four generations of the Sadler family, all with the given

The Town House on the corner of Church Street and Scholars Lane, clearly timber-framed but twice refronted, on the second occasion gaining an embattled parapet.

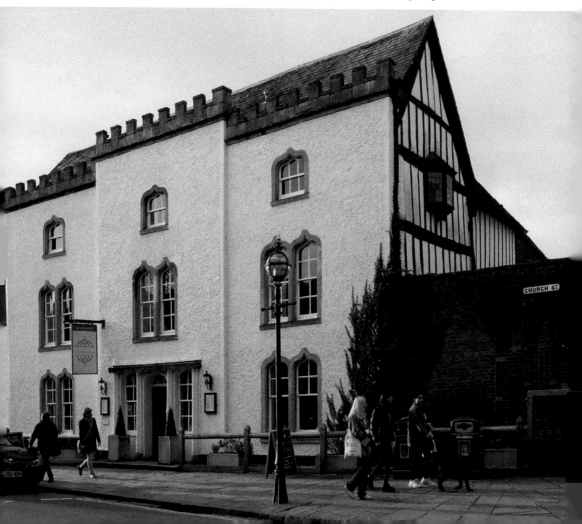

name John. John I, who died in 1582, was a man of some wealth, owning not only this and the adjoining property in Church Street but also the town mills on the Avon and the Bear Inn at the bottom of Bridge Street. John II, who died in 1625, had gone through hard times, including his removal from his post of alderman in 1614 due to his 'decayed state'. John III, who blotted his copybook by fathering an illegitimate child, had meanwhile taken himself off to London where he prospered as a grocer. With his brother-in-law and fellow London 'exile', Richard Quiney, he gave a mace to the Stratford Corporation in 1632. On his death in 1659 his Church Street house passed to his son, John IV, who eventually sold it in 1689.

In 1758 the property was acquired by the twenty-seven-year-old William Hunt, a younger son of the wealthy John Hunt of Tanworth-in-Arden. He was busily establishing himself as a solicitor in Stratford, which included his appointment in 1753 as town clerk. He first threw himself into a project to rebuild the Town Hall in 1767 (No. 33), and then became the local driving force behind the three-day Shakespeare Jubilee held in the town in 1769. This was led by David Garrick, the leading actor of the day, who stayed in this very house. In 1758 Hunt had already indicated his interest in the latest cultural developments, refronting his house in flamboyant Gothic style, complete with ogee-headed windows.

Hunt's grandson, William Oakes Hunt, who inherited the property in 1816, and also became a long-serving town clerk, showed an equal enthusiasm for keeping

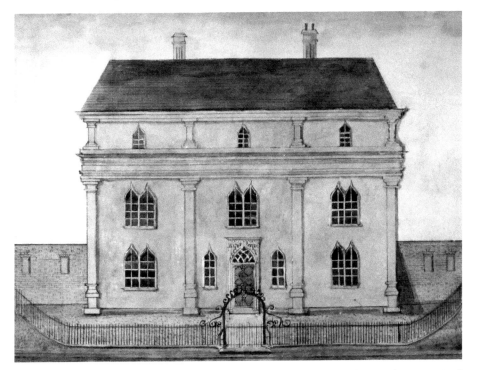

The Town House after its first facelift, incorporating ogee windows. These survived a second facelift but the matching doorway did not. (By permission of Shakespeare Birthplace Trust)

his house looking up-to-date. By the late 1830s, his grandfather's pilasters and elaborate cornice had disappeared to be replaced by an embattled parapet. The ogee windows survived the new treatment but not the Gothic doorway, replaced by the embattled porch, which has likewise disappeared.

22. Ely Place, Ely Street

Another example of a refronting, or possibly successive refrontings, is Ely Place in Ely Street, ending up as something quite adventurous. Its documented history begins in 1615 when it was owned by William Smith, haberdasher, but let by him to Elizabeth Maunde, widow of maltster Edward Maunde, who had died in 1612.

The frontage of Ely Place in Ely Street, complete with a mid-nineteenth-century finish in the 'Tudor revival' style superimposed on a timber-framed building.

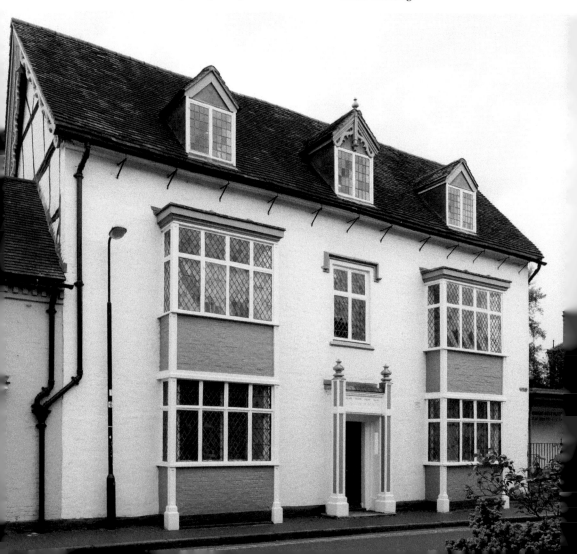

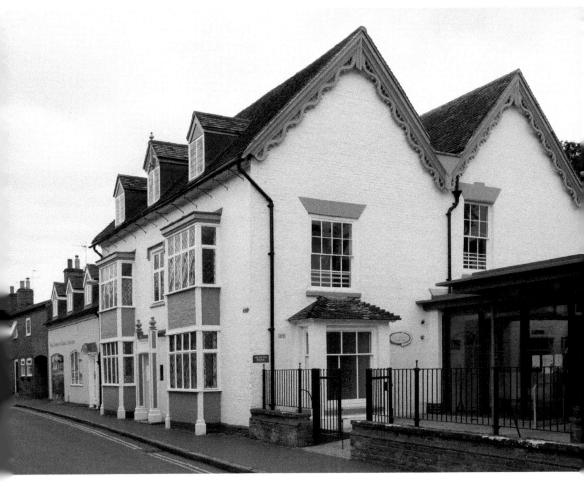

Oblique view of Ely Place, showing the additional bay added at the rear in the early nineteenth century.

It descended in the male, and then female, line of the Smith family until 1790 when sold by Charles Floyer to a schoolmaster, John Rowden Westbury. His successor, John Holmes, another schoolmaster, got into financial difficulties probably caused by his enlargement of the school, refronting it in brick and doubling its depth. The whole complex was known as St John's Place, renamed the Shakespeare House Academy by a later schoolmaster, Revd Samuel Hay Parker. He died nine years later, 'leaving a widow and nine young children (one a cripple) in very reduced circumstances'. The contents of the school had to be sold in the summer of 1846 and three years later the house itself was bought by Edward Gibbs of Stratford-upon-Avon, architect and surveyor. Quite when the final changes were made is uncertain but the barge boards in the gables and the 'Gothic' door, bay windows and porch in revivalist mid-nineteenth-century 'Tudor' style are surely his work (see below, No. 41).

23. Nash's House, Chapel Street

Other restorations reflected a different approach, stripping off the stucco from older timber frames on the growing realisation that a town famed as the birthplace of Shakespeare should look 'Elizabethan' after all, reversing the policy, some hundred years earlier, of concealing timber framing behind brick and stucco. The simple removal of a covering of stucco did only limited structural damage and was not intended deliberately to mislead. However, in cases where the original

Nash's House in Chapel Street, probably the home of Shakespeare's granddaughter Elizabeth after her marriage to Thomas Nash in 1626. It was refronted in 1912.

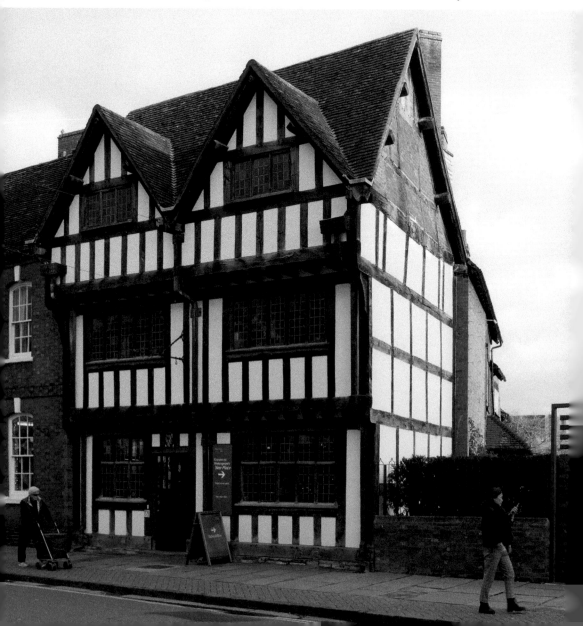

front wall had been completely demolished and replaced by something in Regency style, a more radical approach was required to restore the 'timber-framed' look.

Nash's House, in Chapel Street, is the most obvious town centre example. In the 1590s a building on this site was in the hands of Richard Quiney, head of a family that dominated civic affairs for a hundred years. His family was linked by marriage to the Walfords, and William Walford, that inveterate builder of new properties whom we have met before (see Nos 13, 16) had become the freeholder by the time of his death in 1624. By 1637 the house had passed into the hands of Susanna Hall, Shakespeare's daughter, who had presumably bought it to expand the family's property portfolio, which already included her main residence next door, New Place (No. 31). Susanna's daughter, Elizabeth, had married Thomas Nash in 1626 and the couple may well have lived there until Nash's death in 1647.

Nash left the property to his wife Elizabeth for life but to revert to Nash's family on her death. However, Susanna, still alive, challenged this as contrary to the instructions in Shakespeare's will and it remained her daughter Elizabeth's absolute property until 1670 when, under the terms of her will, it was sold off.

As for the building, its front wall was pulled down, *c.* 1800, and replaced by a brick one which in turn was given a stucco make over, complete with portico, later in the nineteenth century. However, given the link with Thomas Nash and through him with Shakespeare's family, it was decided in 1912 to demolish the nineteenth-century front wall and replace it with an entirely new timber-framed one. So, although the heart of the building is genuinely of *c.* 1600 date, the front wall certainly is not.

The south elevation of Nash's House with a clear view of its original timber frame in both the house itself and the range of buildings to the rear.

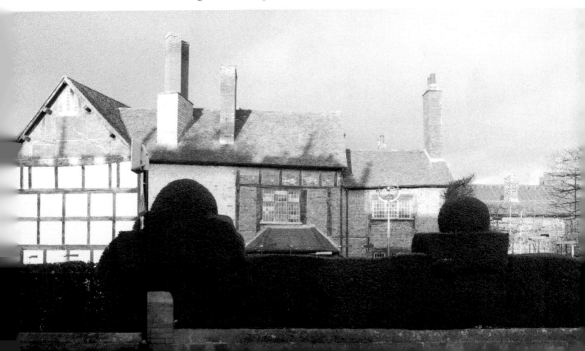

24. No. 21 Bridge Street

Things did not end there. Several buildings in the town, even though new build, were still finished off with a timber frame facing the street. There are two, for instance, in High Street: WHSmith (Nos 4–5) of 1921 and, not to be out done, Nos 6–7 next door, as late as 1937. But the best (and sometimes misleading) example is No. 21 Bridge Street, from a distance fitting in nicely with its neighbour, largely dating from a rebuild following the 1641 fire. However, on closer examination, No. 21 turns out to be a building entirely of 1924, designed by a London architect, Frederick Palmer for the National Provincial Bank. It has a very convincing timber frame on two elevations, jettied to the front and topped with gables. There was no real intention to deceive, though: the rainwater head is clearly dated 1924.

No. 21 Bridge Street, on the corner of Union Street, a timber-framed building of 1924, imitating very successfully a house of Shakespeare's time.

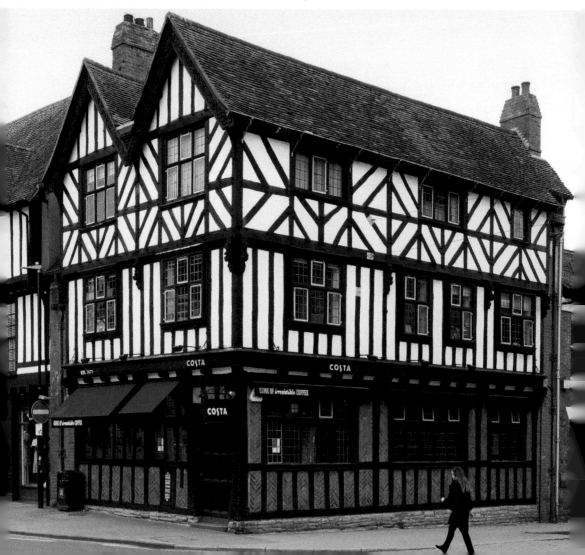

25. No. 1 High Street

In the same category we can include No. 1 High Street. With the house next door running down Bridge Street, it was the home in the early years of the seventeenth century of Thomas Quiney and his wife Judith, Shakespeare's daughter. He had married her in March 1616, shortly before Shakespeare's death. They lived there for thirty years or so. Their three children had died by 1639 and Thomas, with or without his wife, then seems to have moved to London.

The appearance of the house from the street has, like Nash's House (No. 23), been transformed by successive makeovers, from visible timber frame, via a brick

The home of Shakespeare's younger daughter Judith and her husband Thomas Quiney on the corner of High Street and Bridge Street. The Quineys also owned a building on the site of the adjoining property in Bridge Street, making this a prime business site.

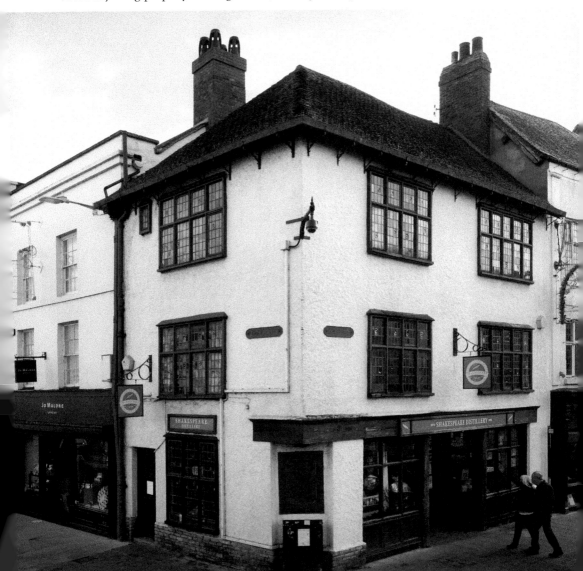

Bronze wall plaque recording the last major restoration of the Quiney house, carried out in 1923 by W. H. Smith & Son.

refronting, then a Regency remake, to the current version following restoration in 1923. During the latest alterations, it was found, as had long been suspected, that it was made up of two separate units with different floor levels. These may date back to the two units recorded as newly built in the 1440s, known for much of the fifteenth and sixteenth centuries as 'the Cage'. This probably indicates that a lock-up was attached to the outside of a building in this prominent town centre spot.

26. Swans Nest, Bridgetown

The mid-seventeenth-century upheavals, mainly the result of the Civil Wars, seem to have led to a downturn in the town's economy and it was not until the restoration of Charles II as king in 1660 that any major building work took place in the town. One of the first of these new houses was the Swans Nest, built by the Clopton family. They lived at nearby Clopton House, which they had largely rebuilt in the 1660s but they also owned land at the far end of Clopton Bridge. This had the potential for commercial use once work had got under way to make the River Avon navigable. First mooted in 1636, work was suspended during the Civil Wars but the project was revived in the 1670s, led by a remarkable man, Andrew Yarranton. In a book published in 1677 he envisaged a scheme that would make Stratford 'to the West of England, Wales, Shropshire and Cheshire as Danzig is to Poland'. At the north-west limit of the Navigation, a town to be called New Brunswick would be built on 30 acres of land owned by John Clopton, now known as Bridgetown. He even included a plan in his book to show where these buildings would go, including a brickworks where the bricks for the

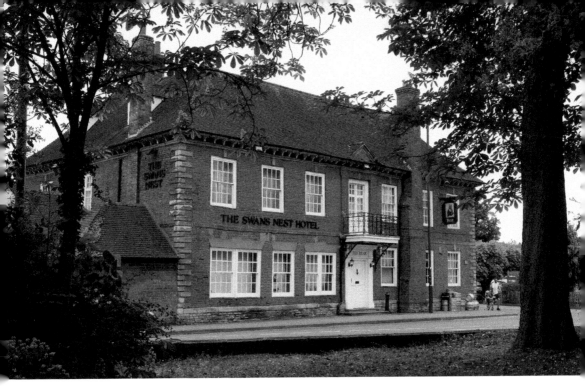

The Swans Nest at Bridgetown, built *c.* 1670 as part of a scheme to develop an inland port.

buildings would be manufactured. John Clopton was clearly attracted by the idea and Yarranton, when his book was published, claimed that the building of New Brunswick was already under way.

Only one substantial property survives today to bear this out, the present Swans Nest, one of two erected, or at least rebuilt, by 1674, when leased to John Woodin who owned the Navigation rights. As was now standard with new buildings of this date, it was built in brick and symmetrical in form, with a prominent eaves line, stone quoins at the angles and topped by a central pediment. The somewhat work-a-day appearance of the Swans Nest, with its miniscule pediment and its symmetry upset by a massive chimney breast, may betray its origin as a building with a commercial use in mind rather than as a gentleman's residence.

Yarranton's scheme never really got off the ground, leaving the Cloptons with a substantial building on their hands. However, it was well placed to serve as an inn, at the south-eastern entrance to the town, and a hostelry known as the Shoulder of Mutton was operating from there by at least 1764.

27. Trinity College, Church Street

Trinity College, on the corner of Church Street and Chestnut Walk, is one of a series of imposing new brick-built houses intended for members of a rising class of town gentry. Many were lawyers, choosing to settle in a quieter part of town, away from the less dignified hustle and bustle of the town centre. It was built,

probably soon after 1700, for a family of wealthy lawyers but substantially altered some 170 years later when it was converted from a gentleman's residence into a private school.

The Rawlins family, originally from Long Marston, had practised as lawyers in Stratford since at least 1610; first, Edmund Rawlins, and then his son, Thomas, born in 1622, who rose to be a Serjeant-at-Law, or elite barrister. At some point the family had acquired a large house on the site of today's Trinity College where they were certainly living by the 1660s. Thomas's only son died childless in 1697, and so on his own death two years later Thomas left his Stratford property to his great-nephew, another Thomas, then aged about ten, with instructions that he be brought up to study law. When Thomas junior died unmarried in 1729, his affairs were in such a sorry state that his property had to be sold to pay off mortgage debts. So who rebuilt the family home, Thomas the elder before he died in 1699, or his great-nephew, Thomas the younger, soon after 1710 when he would have come into his inheritance?

On stylistic grounds, the later date seems more likely, which might also explain Thomas junior's financial difficulties. It is similar in style to the Swans Nest but on a grander scale, and, as early views show, was originally of two storeys with sash windows (plus aprons below them), a prominent pediment,

Trinity College in Church Street, built for the Rawlins family, *c.* 1710. The upper floor was added in 1871 when it became a school. Note the change in the brickwork.

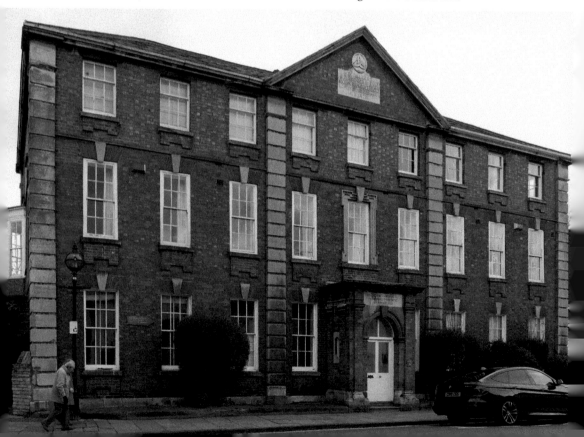

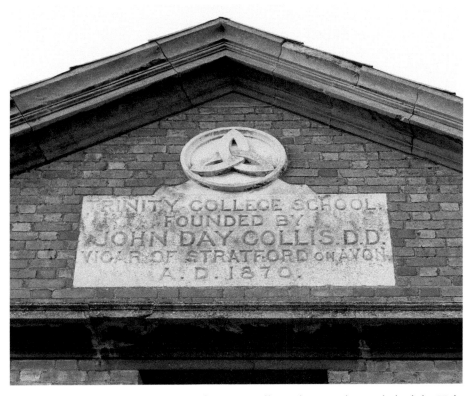

Founder's plaque in the tympanum of Trinity College, showing the symbol of the Holy Trinity. The date differs from the one given on the porch.

emphasised by vertical bands of stonework (instead of just stone quoins), and a fine doorway.

This property remained the residence of town gentry for over 150 years, the last of whom, John Branston Freer, after getting into financial difficulties, sold the house in 1871 to John Day Collis, the retired headmaster of Bromsgrove School and, since 1867, Stratford's vicar. His plan was to turn the house into a school 'for about twelve boys, sons of clergymen and others, with really good voices', who would be trained to sing in the parish church choir – hence the name, Trinity College, still in use today. He added an extra storey to the building (the change in brickwork is clearly visible), incorporated the symbol of the Trinity into the pediment, and replaced the original handsome doorway with a not very appealing porch, inscribed with the date of foundation, 1872. The school opened with six pupils, rising to twenty-two by the end of the month and to 152 by 1876. It was said to have acquired the status of a 'quasi-public school' but, following Collis's death in 1879 and with no endowment to support it, the school developed into a virtual training school for the Civil Service and then a 'crammer' for those planning an officer career in the Army. It was closed in 1908.

28. Mason Croft, Church Street

Mason Croft, next door to Trinity College, is another building of around this time. Its oldest parts might date back to the seventeenth century when the Bartlett family had freehold interests in the site. In 1698 it was acquired by a lawyer, Nathaniel Mason, on his marriage into the Bartlett family and some building work at the rear of the present site may then have taken place. However, following Nathaniel's second marriage into a wealthy family with some landed interests, he rebuilt the front portion of the house, probably to the designs of the Warwick master mason Francis Smith. On 2 July 1724 he took out an insurance policy with the Sun Fire Office to safeguard his new house – the fire mark, issued with the policy, can still be seen high on the front wall. The house was originally symmetrical in the latest style, with a pronounced eaves line and stone quoins at the original angles but in this instance lacking a central pediment. However, in 1745/46 Nathaniel's son Thomas built a flat-roofed extension to the south (left) to house his library.

The house remained in the ownership of the Mason family until 1867. In 1900 it became the home of the famous novelist Marie Corelli, who lived there until

Mason Croft in Church Street, built in 1724 for Nathaniel Mason, now the Shakespeare Institute.

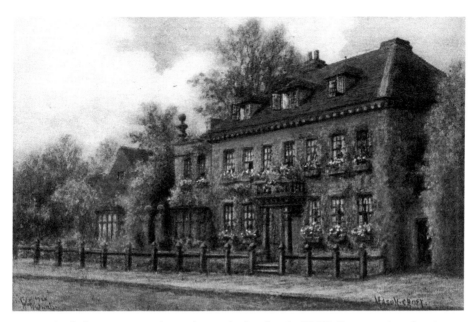

Mason Croft from a watercolour of 1922 by local artist W. W. Quatremain, when it was the home of the famous novelist Marie Corelli, who died there in 1924.

her death in 1924, converting the former coach house, to the left, into a music room. Under her will, she set up a trust in the hope that, after the death of her companion Bertha Vvyer (d. 1941), the house would be preserved for cultural use. This was to some extent achieved when in 1951 it was acquired by the University of Birmingham, to become the home of the Shakespeare Institute.

29. No. 1 Church Street

Also in this part of town, No. 1 Church Street is another smart gentleman's residence built in the early 1690s by William Warry, a dealer in tobacco (a new and very profitable trade) after a recent fire. This may have been at a greater expense than he could afford as he had to mortgage the property, described in 1693 as let to Master William Walford, gentleman. In 1719 it was acquired by Joseph Woolmer, another gentleman, and it later served as a residence of a succession of tenants of similar status. These included the notable antiquary Captain James Saunders, who lived there from 1823 to 1830. He left us a charming drawing of the building, a fine five-bay symmetrical house, with the prominent eaves line and stone quoins that we have seen elsewhere and a fine front doorway. Later two doctors lived there: Thomas Thompson from 1837 and Henry Kingsley from 1855. It was Kingsley who added a two-bay extension to the left and a new porch, upsetting the symmetry of the original building.

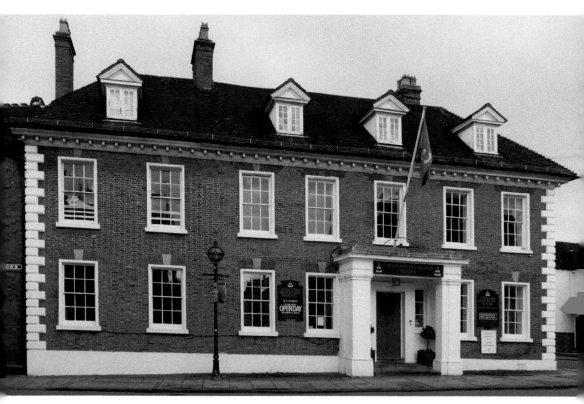

Gentleman's residence at No. 1 Church Street, built for William Warry, a tobacco dealer, but enlarged in the mid-nineteenth century.

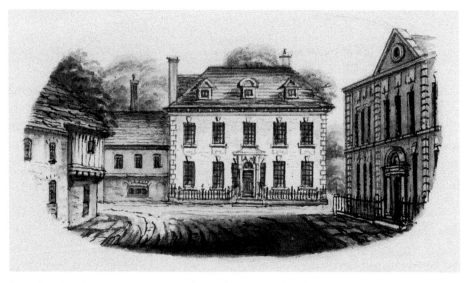

Drawing by Captain James Saunders of No. 1 Church Street, *c.* 1820, before its enlargement. Note Trinity College (**No. 27**) on the right, at that date of only two storeys. (By permission of Shakespeare Birthplace Trust)

3c. No. 5 Old Town

A little way down Old Town is the finest eighteenth-century house in Stratford. In 2000 architectural historian Andor Gomme attributed it on stylistic grounds to master mason Francis Smith (d. 1738). Evidence, in the form of building receipts has since come to light which, whilst not confirming this, do give a precise date for the building of the house, i.e., 1732–34, which at least leaves the option open.

The freehold of the land on which the building stands belonged to the Stratford Corporation and, when a new lease of the premises was being negotiated with a local gentleman Abel Makepeace, it was made a condition that within three years he would replace the tumble-down cottages on the site with a single house. In a draft deed of July 1742 we read of a newly built brick house lately in the tenure of Abel Makepeace, so there is no doubt that he carried out the work. He was evidently using money obtained as the result of his recent marriage to the elderly

No. 5 Old Town, a fine house built in the early 1730s for gentleman-adventurer Abel Makepeace.

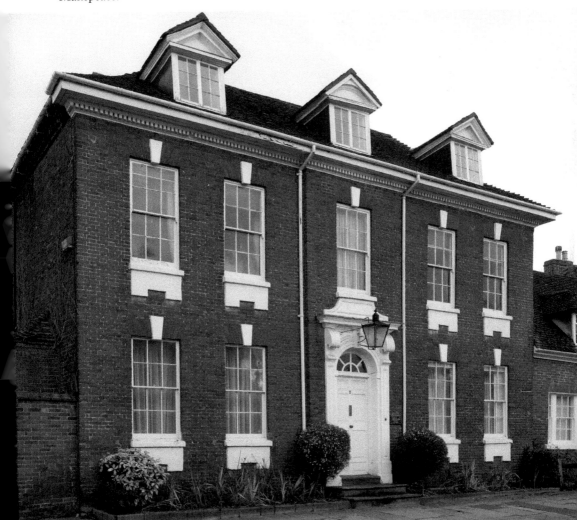

but wealthy widow, Martha Clopton, leading to a lively legal battle between Makepeace and the rest of the Clopton family.

Of all the buildings in this part of town, here alone is a house which has survived more or less as built, albeit with more modern dormers. A certain elegance had crept in by the 1730s, notably in the design of taller more graceful windows and the decision to dispense with heavy stone quoining.

31. New Place Garden and the Boydell Monument

There was once another very fine town house of this period, New Place, dating from *c.* 1700. It had replaced a house built by Hugh Clopton (see Nos 2 and 5) in the 1480s or 1490s as his town residence. This earlier building was the substantial property that William Shakespeare bought in 1597 and where he died. The house then descended in his family until the death of his granddaughter Elizabeth in 1670 and her husband Sir John Barnard in 1674. It was then sold to Sir Edward Walker, who settled it on his only daughter, the wife of Sir John Clopton, so bringing it back into the possession of the family who had built it.

However, it is a measure of William Shakespeare's limited reputation at that time that John Clopton, around 1700, proceeded to demolish the poet's Stratford home to replace it with a second New Place, a handsome symmetrical house (if we can trust early views) that he settled on his second son Hugh. This new house fared even worse than its predecessor. Following Hugh's death, it was sold in 1753

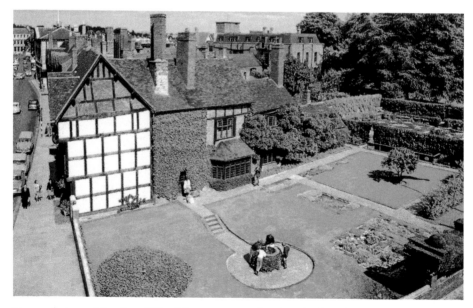

Postcard view of the site of New Place, *c.* 1970, showing the foundations of Shakespeare's House. These were preserved in a garden setting until the remodelling of the site in 2016.

to Revd Francis Gastrell, who a few years later demolished it as the result of a quarrel with the Stratford Corporation. This has left very little, if anything, on site in the way of building and for over 250 years it has remained a vacant plot, for much of that time serving as a garden to Nash's House next door (No. 23) with some of the foundations of the previous houses exposed. It was remodelled to its present form in 2016 to mark the 400th anniversary of Shakespeare's death.

As the result of an earlier campaign in the 1860s, led by the Shakespeare scholar James Orchard Halliwell, the site had already been turned into a memorial to Shakespeare, not only the site of the house itself but also the Great Garden to the rear, much of which Shakespeare had also owned. In the process an eighteenth-century monument from a building with strong Shakespearean associations was acquired, the magnificent marble sculpture by the distinguished artist Thomas Banks, officially known as 'Shakespeare seated between the Dramatic Muse and the Genius of Painting'. This had originally stood over the entrance to John Boydell's Shakespeare Art Gallery in Pall Mall, London, which had opened in 1789

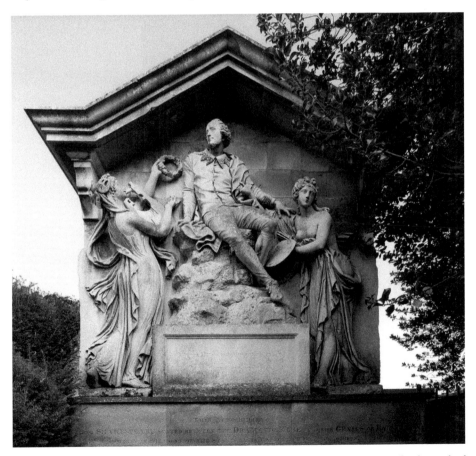

Marble sculpture of William Shakespeare by Thomas Banks, 1789, now at the far end of the Great Garden of New Place.

and for a few years had proved a popular attraction. However, following a period of decline, it was forced to close in 1805. The premises were then reopened as a gallery under the management of the British Institution but with Banks's sculpture still in place. When in 1867 this second gallery closed, and demolition of the building was imminent, the sculpture was acquired by Charles Holte Bracebridge of Atherstone Hall, who presented it to the town of Stratford-upon-Avon in 1871. It was then installed at the far end of the Great Garden.

32. Summer House, Avonbank Garden

Another major town building of which very little survives today was Stratford College, the home of the body of priests who served the parish church from the mid-fourteenth century until the Reformation. The building, standing to the west of the church (see Plan), then became the residence of wealthy gentry and, from drawings made around 1800, had clearly been added to over the years. On demolition some stones were salvaged and then used to build the summer house in the garden of Avonbank, a nearby house adjoining the churchyard (see Plan).

The Avonbank summer house, built *c*. 1800 with stonework salvaged when the College was demolished. The Royal Shakespeare Theatre, the present owner, has recently filled in the open arches with painted panels depicting scenes from Shakespeare's plays.

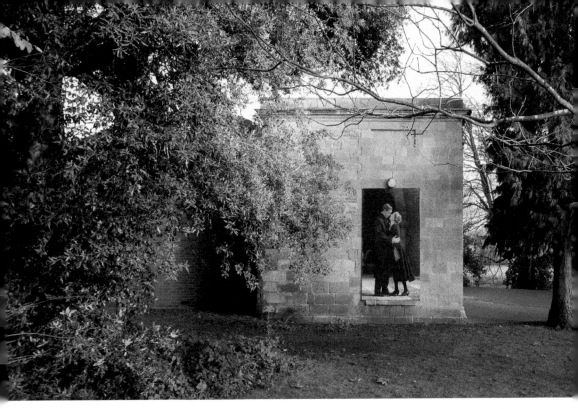

One panel on the side of the summer house gives a remarkable *trompe l'oeil*. The oval extension to the left is Henry Hakewill's work, once built onto Avonbank but moved from there in 1866 when the house was demolished.

Avonbank has likewise since been demolished but the summer house survives to this day, an interesting reminder of both the College and Avonbank, two fine houses that once graced Old Town. The oval extension to the rear of the summer house was the work of the well-known architect Henry Hakewill. It dates from *c.* 1820 but again it is not in its original position. It was designed as an extension to Avonbank and in 1866 was salvaged when this house too was demolished and then built onto the summer house.

The demolition of the College was followed in the 1820s by the sale of its grounds and the development of a network of streets to the west, the nearest of which, College Street and College Lane, remind us today of what once stood there. Near their junction is an early building, now converted to residential use, which must once have been an outbuilding of some sort attached to the College.

33. Town Hall

The Town Hall, on the corner of Chapel Street and Sheep Street, is the most prominent eighteenth-century building in the town centre. It dates from 1767 and, as befitted a building to which great civic pride was attached, was constructed in stone. It was probably designed by Robert Newman of Whittington in

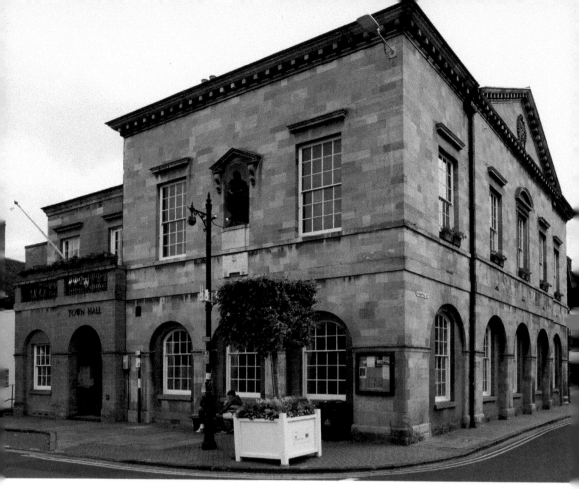

The Town Hall today, on the corner of Chapel Street and Sheep Street, built in 1767.

Gloucestershire, the mason who signed the building contract. Its forerunner, built in the 1630s, had been seriously damaged by an explosion of gunpowder stored there during the Civil Wars following which it had only been patched up. The new building, like its predecessor, was originally open on the ground floor, for use on market days, with an Assembly Room above.

In 1863 the open arches were filled in to create further rooms on the ground floor used, among other things, for meetings of the Stratford Corporation, which had previously been held at the Guild Hall in Church Street (No. 3).

Gracing a niche in the Sheep Street frontage is a statue of Shakespeare by John Cheere, presented to the town by actor David Garrick in response to an approach made by the Corporation. Garrick not only presented a statue but also organised a three-day festival in the town in September 1769. Although the event was plagued by bad weather, it is often seen as the starting point of Stratford's reputation as an interesting place to visit.

The words 'GOD SAVE THE KING' were apparently added to the Chapel Street frontage to commemorate a later event, either a coronation or George V's Silver Jubilee.

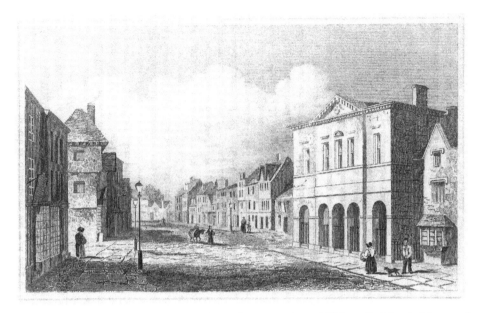

Engraved view of Chapel Street and High Street, from William Smith, *A New and Complete History of the County of Warwick*, 1829. The ground floor of the Town Hall was then an open area, albeit railed off.

34. No. 21 Chapel Street

As we have seen, much of Stratford's eighteenth-century residential building took place close to the Church Street/Old Town junction, an area away from the busy town centre where the rising class of town gentry preferred to settle. Surviving buildings in the town centre were less grand and more functional, sometimes retaining early building work at the rear. A good example is No. 21 Chapel Street (Chaucer Head Bookshop) looking almost the same from the street as when it had its last major facelift over 200 years ago, a notable achievement for a building in commercial use for much of that period.

The front section of the house retains some internal evidence of a timber-framed building dating back at least to the sixteenth century but the best evidence of this early work is to be found at the rear of the building. In Shakespeare's day it was the home of Robert Gibbs, a yeoman, until his death in 1596, and then, more significantly, of Julius Shaw, a wealthy yeoman and wool merchant, who served as high bailiff in the year 1615/16. Shakespeare, who lived almost next door at New Place, called on him in that year to witness his will.

The building underwent a major change soon after 1790 when it was leased to Charles Henry Hunt, Stratford's young town clerk. By then the building was in bad shape and, under the terms of his lease, Hunt agreed to rebuild at least the front part. This accounts for its appearance today, its locally made chequered brick very characteristic of building work in Stratford at this time.

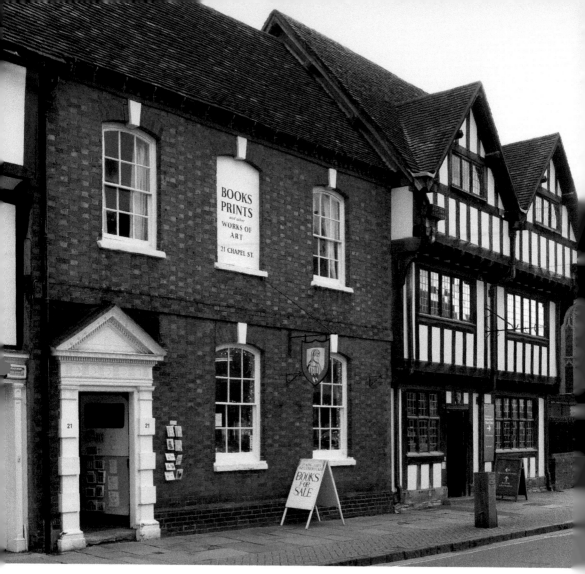

No. 21 Chapel Street, the home of Julius Shaw in Shakespeare's day, but, after alterations in the 1790s, first a bank and then a Public Dispensary. Next door is Nash's House (**No. 23**).

Hunt had many business interests, one of which was to reopen No. 21 Chapel Street as the town's first bank. However, he had a tendency to over-reach himself in business matters and by 1800 was declared bankrupt. One of his principal creditors was Edmund Battersbee who, with William Morris, then took over the business. They were hardly more successful: in 1818, after Battersbee's death, Morris himself was declared bankrupt – one of many bank failures across the country at that time – and in 1826 all his property was eventually sold off.

In the meantime, in 1823, the old bank house had been taken over for a very different use, this time as a charitable Public Dispensary for the benefit of the poorer townspeople faced with sudden illness or injury. The young Dr John Conolly, who briefly settled in the town in the 1820s – and better known today

for his pioneer treatment of the mentally unwell – was an enthusiastic supporter. Two small wards provided in-patient care but it was not long before this accommodation proved inadequate and in 1837 the enterprise was moved into new premises in Chapel Lane (No. 35).

In 1902 the building entered another interesting period in its history when it was taken over by the prominent literary scholar and publisher A. H. Bullen, to become the home of the Shakespeare Head Press, specialising in fine printing, particularly of new editions of work from the Shakespeare period. Bullen died in 1920 and is buried in Luddington churchyard though the business, taken over by a small consortium, continued at the premises until 1930. It continues today as a bookshop.

35. 'Union Club', Chapel Lane

In 1837 the Public Dispensary in Chapel Street (No. 34) was moved to purpose-built premises in nearby Chapel Lane. The site had originally housed the town's new gasworks but complaints about the smell obliged the managers to relocate operations to the outskirts of the town. Erected in its place was this neat pedimented classical building to provide the Public Dispensary with a new and more spacious home. This allowed for increased in-patient care but, despite enlargements in 1858, the accommodation again proved insufficient and in 1884 the Dispensary was once again on the move, this time to the town's first purpose-built hospital, since demolished, at the junction of Alcester and Grove Roads, on the site of the present hotel.

The former Union Club in Chapel Lane, built in 1837, now the offices of the Royal Shakespeare Company.

The Chapel Lane building was taken over to house a newly formed 'Union Club' with the worthy Victorian intention of providing young middle-class men with premises where they could engage in respectable pastimes. Its membership was said not to reflect any political bias, although, by 1900 at least, some conservative-leaning opinion can be detected. The club survived into the 1970s, by which time it had acquired some less well thought-out extensions. It has since been converted into offices for the Royal Shakespeare Company.

36. Nos 7–8 Rother Street

By the end of the eighteenth century a different architectural style had begun to make itself felt in the outward appearance of both residential and commercial properties. A good example is Nos 7–8 Rother Street, a fine pair of houses built in the 1790s – at the expense of wealthy Westminster upholsterer Henry Turner, presumably with local connections – who then leased them out to well-to-do widows. They too were in that locally made chequered brick characteristic of the

The plain three-storey façade of Nos 7–8 Rother Street, built in the 1790s in chequered brickwork, now the Hotel du Vin.

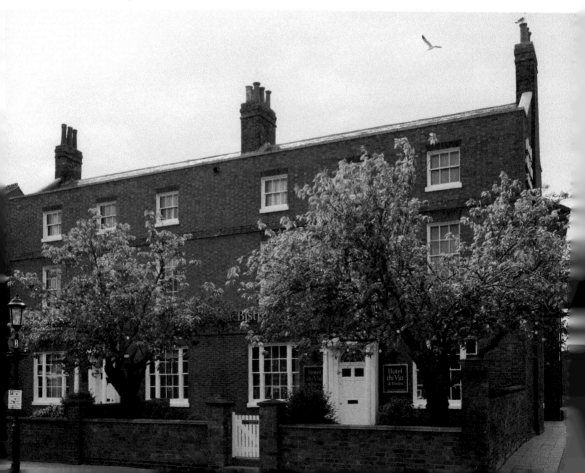

time (see No. 34) but their overall appearance from the street was very different. The increasing use of slate instead of tiles led to shallower pitched roofs allowing for three full storeys to be incorporated into the façade without increasing the overall height of the building. There was no longer any need for a decorative 'eaves line', dormer windows went out of fashion, and often even the roof itself was hidden behind a parapet.

37. Bridge Street Hostelries

The eighteenth-century turnpiking of the county's main roads led to an increase in traffic and this had inevitable knock-on effects in Stratford, not only in terms of congestion but also in the expansion of the hostelry business, especially in Bridge Street. This thoroughfare became the focal point of improvements designed to give this major entrance into the town a more fashionable look. The bridge was widened in 1812 (No. 5) and a row of ramshackle buildings, known as Middle Row, which had evolved out of market stalls set up in the street from medieval times, was demolished in stages. The first buildings to go were at the bottom end and by 1850 only a few houses remained. At the same time, many of the buildings lining the street were rebuilt and refronted with stucco (a cheaper substitute for stone) in imitation of the large-scale development at nearby Leamington Spa. This created the Regency character the street still enjoys.

Two adjoining hostelries, the Red Horse (now Marks & Spencer) and the Golden Lion (next door), were clear beneficiaries of these improvements and their

Former Red Lion Hotel, now Marks & Spencer, in Bridge Street, and, to the right, the former Golden Lion Hotel with four gables.

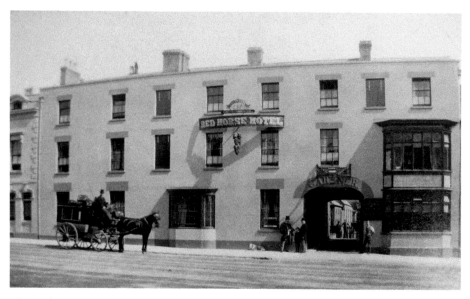

The Red Horse in 1890. Note the original archway through to the rear, now blocked by a portico formerly outside the Shakespeare Hotel (**No. 17**). (By permission of Shakespeare Birthplace Trust)

frontages still serve as a reminder of their former dominance in the street scene. An inn had existed on the site of the Red Horse since at least the beginning of the seventeenth century but it was in the early nineteenth century that it was refronted in the new Regency style and then extended westwards into an adjoining property. Early views show the frontage pierced by a passageway for coaches, filled in when, in the 1920s, the portico we see today was moved from outside the Shakespeare Hotel in Chapel Street following work to the frontage there (No. 17).

The Golden Lion next door also did well. As with the Red Horse, a small inn had functioned on part of the site from early days but in the late eighteenth century it too expanded. Also like the Red Horse, it was refronted in the 1820s, though more attractively and retaining its central passageway. It was later absorbed into the Red Horse, when it too lost its arched passageway, and remained in that use into the 1970s.

38. Market House, Bridge Street

The Market House at the top of Bridge Street (now Barclays Bank) was part and parcel of these improvements. It was built in 1821, replacing an ancient structure that had stood on the corner of Wood Street and High Street. The contract for the new building was signed on 3 July 1821 and the foundation stone laid on 19 July, as part of the celebrations held in the town to mark George IV's coronation. No architect was named in the surviving documentation. Instead, the contract was

Former Market House at the top of Bridge Street, built in 1821 and originally open on the ground floor.

simply signed by William Thompson, a plasterer, and William Izod, a plumber. From the outside, the building still looks very much like the one built, with one important exception. As befitted a replacement market cross, the ground floor of the new hall was originally left open to accommodate market stalls, accessed via three round-headed openings. A room above was put to various uses but even by the 1860s there was talk of demolishing the whole building and replacing it with something more 'dignified'. This radical solution, and several that followed, came to nothing and in 1907 the building was leased to the United Counties Bank. It then underwent a thorough makeover, including the permanent infilling of the original open archways, and at the same time preserving for us an important symbol of the original purpose of that central space in the town.

39. Nos 14–15 Rother Street

Houses too were going up in the new style pioneered in such buildings as Nos 7–8 Rother Street (No. 36), their three storeys incorporated into a simple, often severe, façade. Nos 14–15 Rother Street nearby were built in 1830 and

could easily be mistaken for the Regency villas then under construction in the rapidly developing Leamington Spa. This building began life as two villas, with a central archway through to the rear, and separate doorways where the rectangular windows now are, captured in a charming drawing by Hephzibah Harris. One of these houses accommodated the town's first Catholic chapel under the direction of the eccentric Alfred Dayman (see No. 46). However, in 1876 both houses were converted into a single building to serve as a Nursing Home and Children's Hospital run by a charity set up in 1871 to carry out nursing visits to the sick poor. This had quickly developed into an institution providing beds for convalescent women and sick children. Initially it operated from a converted house in Tyler Street but in 1876, largely as the result of a generous donation of £4,000, it was able both to purchase the freehold of the two villas in Rother Street and then to carry out the necessary refit. It continued in this use until shortly after the Second World War and the inauguration of the National Health Service.

The Playhouse in Rother Street, built in 1830 as twin villas but converted into a single building in 1876 to become a nursing home.

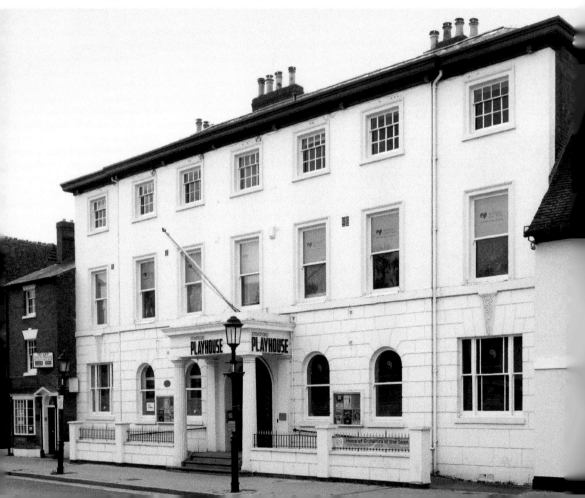

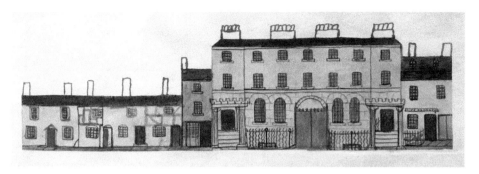

Drawing by Hephzibah Harris of Nos 14–15 Rother Street whilst still two houses, 1860s/70s. (By permission of Shakespeare Birthplace Trust)

40. The Fold, Payton Street

The Fold in Payton Street was another residential building in the popular Regency style and is still occupied as two separate dwellings. In the 1820s Payton Street and two other streets linking with it (John Street and Tyler Street) were being developed to the north of the town, one of the first incursions into open land outside the original borough boundary. Named New Town, it was intended as a fashionable suburb for the well-to-do and soon became lined with many pleasant Georgian buildings, though none quite so grand as the Fold.

The Fold in Payton Street, a symmetrical pair of Regency houses built in the late 1820s.

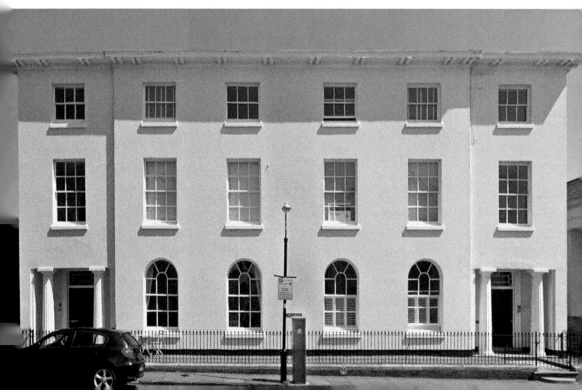

Elegant Doric columns and Palladian window at The Fold.

Though the area quickly became a veritable hornets' nest of Victorian clergy and solicitors, the project did not take off in quite the way intended and the remaining streets on this northern fringe of the town (Great William Street and Shakespeare Street) were, and still are, characterised by terraces of smaller artisan dwellings.

41. No. 6 Old Town

Adoption of the Regency style was not the only option for those wishing to build in the latest fashion. Another option was to resurrect motifs from the earlier Elizabethan period, featuring gables with decorated barge boards and 'Tudor' lintels over the windows. Stucco, however, could still be used for a fashionable finish. In Stratford, this enjoyed a short period of popularity, perhaps due to the fact that the architect George Hamilton had settled in the town in the 1830s. The Pump Rooms at the nearby Bishopton Spa, in 1837 undergoing fashionable development in similar style, are certainly his work. Within the town, the best example is No. 6 Old Town, also built in 1837, and at the very least inspired by him, though there are some others across the road at Nos 17–19 Old Town (in chequered brick) and in Warwick Road (until recently the Grosvenor Hotel) with a stucco finish.

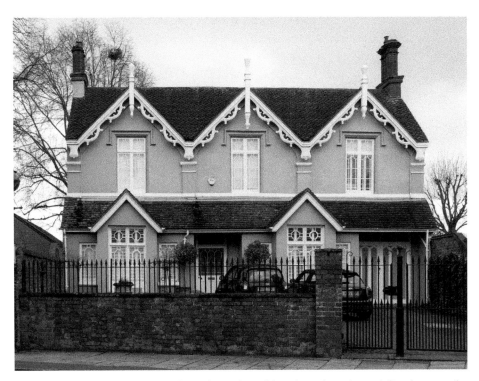

No. 6 Old Town of 1837 with Tudor-style gables, bargeboards and lintels over the windows.

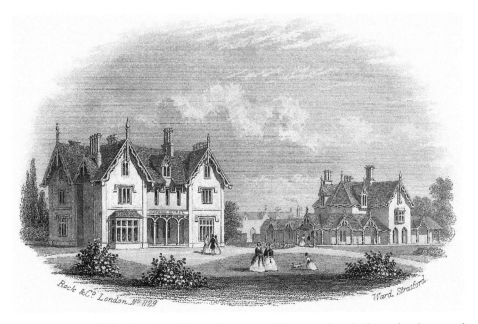

Engraved view of the Hotel and Pump Rooms at Bishopton Spa, built to the designs of S. C. Daukes and George Hamilton. From Lock & Co., *Views of Stratford-upon-Avon*, 1838.

42. No. 15 Church Street

To round off the story of fashionable residences in the town centre, there is No. 15 Church Street, a neo-Georgian house of 1911, built for Dr Henry Ross and designed by local architect Albert Calloway. It is the only example in the town of this revivalist symmetrical style and still bears the date of its original construction. It survived as a separate building for twenty years or so but was later taken over by the National Farmers Union Mutual Insurance Society, founded in Stratford in 1910, and extended southward along the street in two main stages, the first in 1927–29, and then in 1954–59. The architects respected Calloway's materials and general style but their overwhelming extensions have not worked to the advantage of his original design. When, in 1984, the NFU moved to new purpose-built headquarters in Tiddington the building in Church Street was taken over by Stratford District Council.

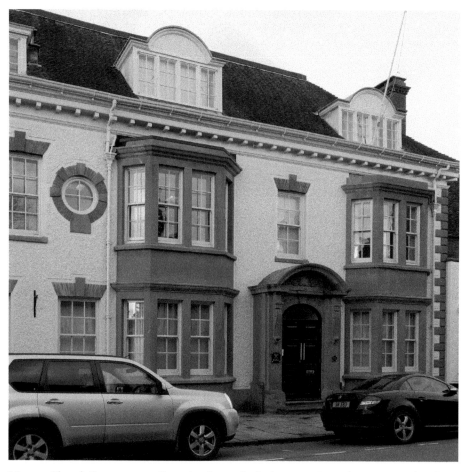

No. 15 Church Street, a neo-Georgian house built in 1911. Its style was copied in later office extensions to the south.

43. Tramway Bridge and Cox's Timber Yard

Stratford had prospered for centuries as a market town but in the early 1800s the effects of the Industrial Revolution, especially in the transport of coal and grain, began to have an impact on the townscape. A canal reached the town in 1816, with a canal basin on the Bancroft at Bridge Foot linking Birmingham with the Avon Navigation. A second basin (now filled in, though a connecting arm remains) followed in 1827. In 1823 a brick bridge was constructed for a horse-drawn tramway, which reached Stratford in 1826, linking the town initially to Moreton-in-Marsh, with a branch to Shipston opened in 1836. This led to the construction of wharves round the canal basins, linked together by a network of tramlines. Some businesses also opened there, notably James Cox's timber yard established in 1830 as a joint venture with Edward Flower, who set up a brewery further along the canal in the following year, becoming the town's biggest employer.

Cox's timber yard continued to operate on its original site into the 1980s, using as its offices in its later years the toll house at the northern end of Clopton Bridge (No. 5). Its buildings, including a weather-boarded timber drying shed and other brick buildings, including a tall chimney, were later converted into a restaurant and ancillary facilities.

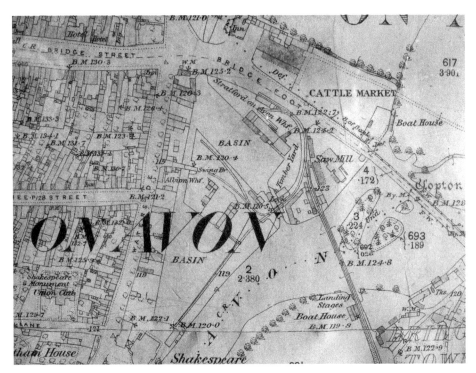

Bridgefoot in 1885 (first edition of OS map, 1:2500) showing the network of tramways, the canal and its two basins, and the wharves and warehouses that established themselves there.

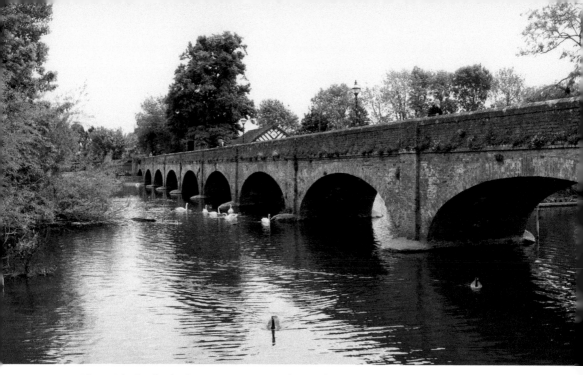

Above: The bridge built in 1823 to carry a horse-drawn tramway over the Avon to connect Stratford with Moreton-in-Marsh.

Below: The site of James Cox's timber yard at Bridgefoot with easy access to the river, canal and tramway.

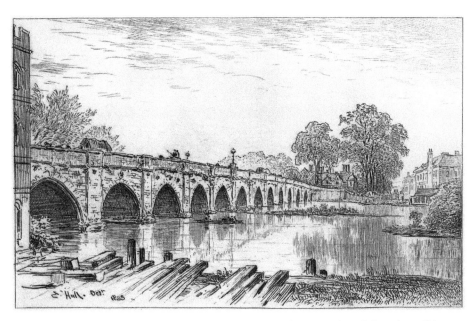

Drawing by Edward Hull from Cox's Yard, 1883. To the immediate left is the toll house, and across Clopton Bridge is Alveston Manor (left) (**No. 11**) and the Swans Nest (right) (**No. 26**). From Sidney Lee, *Stratford-on-Avon*, 1885.

44. M. C. Ashwin's Warehouses, Union Street

One of the by-products of the development of New Town (see No. 40) was the driving through of a new road (Union Street) in the early 1830s to connect Guild Street and the new suburb to the town centre. This new road soon became lined with buildings, residential on the east side but on the west by the only block of what might be called 'industrial premises' to survive in the town centre. It was built by 'Ashwin and Co.', not a manufacturing concern but wholesalers dealing in commodities now more easily transported around the country. The business was founded by Thomas Ashwin, with wharves down by the canal and dealing initially in coal and corn. However, by the time of his death he was also dealing in 'guano, gypsum, lime, bones, oil-cakes, linseed, rock and agricultural salt, stone, cement, blue and fire bricks, draining pipes etc'.

With the arrival in Stratford of the railways in 1859–60, headquarters near the canal became less important, and when, in 1861, Thomas's son Manley Cornell Ashwin acquired the freehold of No. 21 Bridge Street (No. 24), with its garden running down Union Street to Guild Street, he began developing it for business use. The work was carried out in phases, the first a red-brick office-type block in a restrained and conventional manner but followed by a more adventurous symmetrical three-storey warehouse topped with a pediment and flanked by a tower in Italianate style. A further major phase, of 1868, extended the development

Ashwin & Co.'s warehouses in Union Street, built in stages between 1861 and 1898.

in this more obviously Victorian style down the street, rounded off in 1898 with a final block to bring it down to the line of Guild Street. The whole range is now divided into smaller units but it remains an important reminder of the town's expanding commercial interests.

45. The Baptist Chapel

As in all English towns, and in many villages too, an increase in the number of religious Nonconformists – i.e. people who rejected the hierarchical set up of the established Church of England – led to the building of new places of worship. First off the block were the Independents, or Congregationalists, with a history reaching back to the Toleration Act of 1689. In Stratford, they had built a chapel in Rother Street by 1712, later moving to new premises further along the street (now the United Reformed Church). There was then a long gap before others came on the scene, notably the Wesleyan Methodists, meeting in temporary accommodation from 1819 until they could afford, in 1835, to build themselves a chapel on the corner of Birmingham Road and Shakespeare Street (now a restaurant).

The original Congregationalist chapel has been demolished and the Methodist chapel converted to other uses, but the Baptist chapel, going up at the same time as the Methodists', continues in its original function. The Baptists had enjoyed remarkable success in recruiting members since starting up in makeshift premises

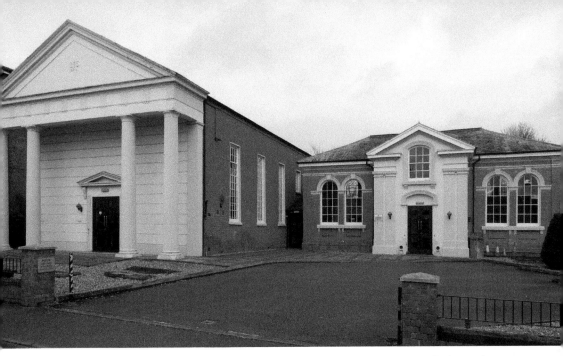

Baptist Chapel in Greek Revival style in Payton Street, built in 1836, with hall alongside added in 1861.

in 1826. They constituted themselves formally in 1832 and then, mainly through the support of the well-to-do James Cox, owner of the new timber yard at Bridgefoot (No. 43), were able to buy a site in Payton Street on which to build a handsome Greek Revival chapel, complete with portico, which opened in 1836. The architect is not known, though Thomas Heritage, who combined building work with an architectural practice, was certainly involved in the extension, which was required seven years later to cope with increased numbers. Sunday schools were provided in a neighbouring block, built in matching style in 1861 to the designs of local architect Joseph Lattimer.

46. Roman Catholic Church

It was not only the Nonconformists who wished to steer clear of the Church of England. There were also, of course, the Roman Catholics. Following the Reformation Catholics had been discriminated against for over 300 years, and, although freedom of worship had long been tolerated, open expression was still not common, even by the early nineteenth century. Stratford's Catholics were initially catered for by priests from a modest Benedictine Mission at nearby Wootton Wawen. However, in 1849, it was decided that a town of Stratford's size merited a recognised place of Catholic worship, leading to the purchase of a site in Warwick Road, on the edge of town. No building work was immediately undertaken and, during 1851–57, the project was interrupted by a 'rival' enterprise, under the leadership of the eccentric Alfred F. Dayman, who, with the

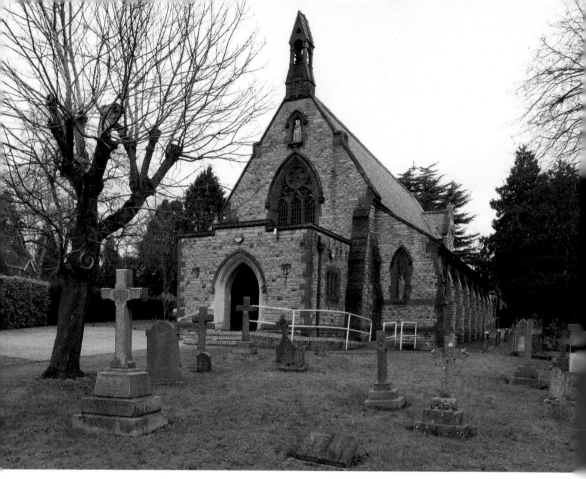

Above: St Gregory's Catholic Church in Warwick Road, built in 1865/86 to the designs of Edward Welby Pugin.

Below: Interior of St Gregory's Church after recent restoration.

local bishop's support, established a chapel in a house in Rother Street (No. 39). Only when this project failed was further thought given to the Warwick Road site. By 1865, after some years of fundraising (during which the congregation met in sheds and other makeshift premises), enough money had been raised to build a new church, designed by the thirty-two-year-old Edward Welby Pugin (son of the better known Augustus Welby Pugin), the architect of over a hundred Catholic chapels. This was only a modest commission, but is a very competent piece of work, although not enhanced by the remodelling of the west front and addition of a porch in 1957. The foundation stone was laid by the mayor, James Cox, son of the prominent timber merchant and staunch supporter of the Baptists (No. 45). No doubt this caused some family tensions.

47. Shakespeare Memorial Theatre

Some late nineteenth-century additions to the Stratford townscape were associated with the burgeoning Shakespeare industry. This led to the craze already discussed of stripping brick and stucco off timber-framed buildings (or even rebuilding the frontages entirely) to give them a more 'suitable' Tudor look. But alongside this was the introduction of new features in homage to Shakespeare in a more exuberant 'high Victorian' style, inspired by a revived popularity of the 'Gothic'. The pace was set by the Shakespeare Memorial Theatre, opened in 1879, built largely at the expense of Charles Flower, a wealthy brewer and son of the founder of the business (see No. 43). This remarkable building, designed by Edward

The original Shakespeare Memorial Theatre was opened in 1879. A postcard view from across the river, *c.* 1900. Note the original location of the Gower monument (**No. 50**).

Dodgson and William Unsworth, was unlike anything else in the town at that date: an amalgam of towers, gables, domes, patterned brickwork and some timber framing. In 1888 the Gower Monument to Shakespeare (No. 50) was placed in its garden.

This unique contribution to the town's architectural heritage was seriously damaged by fire in 1926 but enough was left standing to remind us of its original flamboyant character. This included the shell of the burnt-out auditorium, which

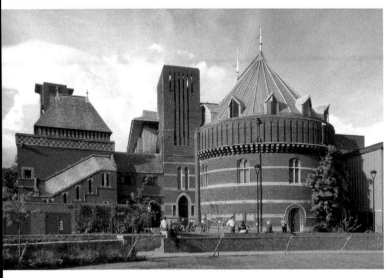

Left: The Royal Shakespeare Theatre from the south, showing those parts of its predecessor (the Shakespeare Memorial Theatre) that escaped the fire of 1927.

Below: The fine 'Gothic' Library and Museum of the Shakespeare Memorial Theatre, from Waterside, with terracotta panels by Paul Kummer.

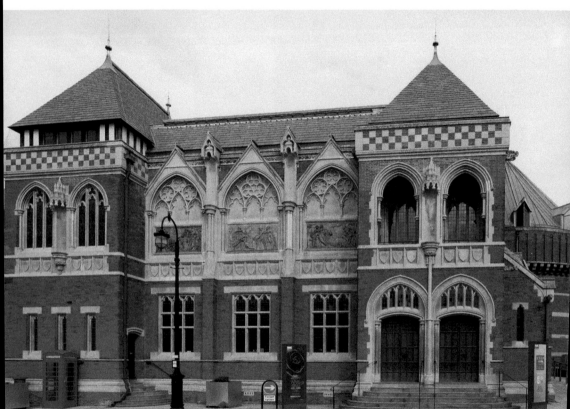

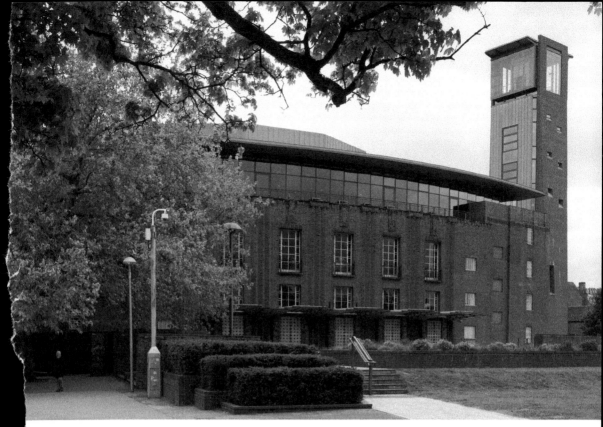

Elizabeth Scott's austere façade from the 1932 rebuilding of the theatre, retained during radical alterations to the building (completed in 2010), which included the addition of a campanile tower.

in 1986 was restored to something like its original external appearance when a new theatre, the Swan, was built inside it. The 1926 fire also left virtually intact the Library and Art Gallery completed in 1880–81 – lavishly Gothic and basically symmetrical with an open loggia at the south end and a recessed centre with splendid terracotta panels by Paul Kummer depicting the three Shakespearean themes of History, Tragedy and Comedy.

Following the 1926 fire, much of the theatre was rebuilt to the austere modernist designs of Elizabeth Scott, reopening in 1932. It was further remodelled in 2006 and 2010 including the construction of a new tower.

48. HSBC Bank, Chapel Street

The present HSBC bank, built in 1883 for the Birmingham Banking company, was in similar flamboyant Gothic. It was designed by Birmingham architects Harris, Martin and Harris in a style typical of buildings appearing at that time in the heart of Birmingham. Not to be outdone by the theatre, it too had an elaborate terracotta frieze, this one designed by Samuel Barfield of Leicester, depicting fifteen scenes from Shakespeare's plays and, over the doorway, a mosaic including William Shakespeare himself, modelled on the bust in Holy Trinity Church.

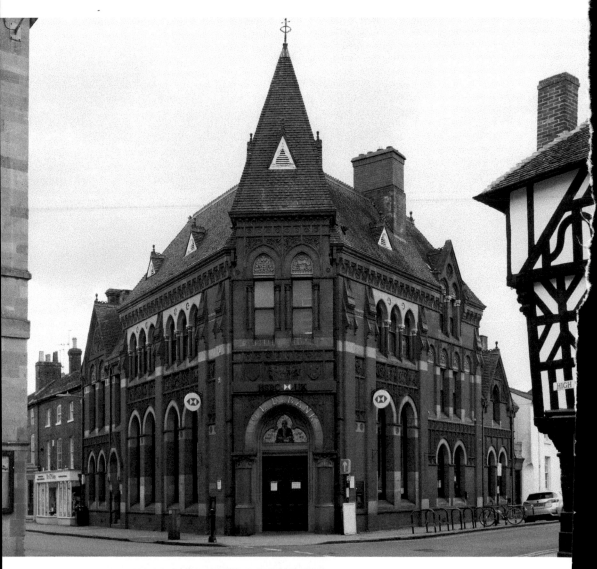

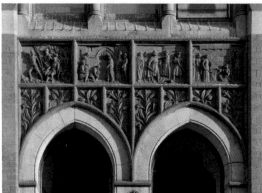

Above: The HSBC bank on the corner of Chapel Street and Ely Street, built in 1883 in a flamboyant Gothic style.

Left: Four scenes from Shakespeare's history plays depicted in the terracotta frieze by Samuel Barfield: (left to right) Henry V, Richard II, King John and Richard III.

49. Shakespeare Memorial Fountain, Rother Market

A third building in this style, also with Shakespearean associations but of a slightly
later date, was the Shakespeare Memorial Fountain in Rother Street, complete
with ornate horse and cattle drinking troughs, in the middle of the Rother Market.
It was paid for by the wealthy American newspaper millionaire George W. Childs,
and designed by another Birmingham architect, Jethro Cossins, with carvings
by Robert Bridgeman. The quotations from Shakespeare plays were deemed
suitable for a fountain sited in the old cattle (or rother) market even though, in
the interests of Victorian good taste, this had recently been moved to Bridgefoot. It
was unveiled to mark Queen Victoria's Golden Jubilee in 1887 and was dedicated
to the great actor Sir Henry Irving.

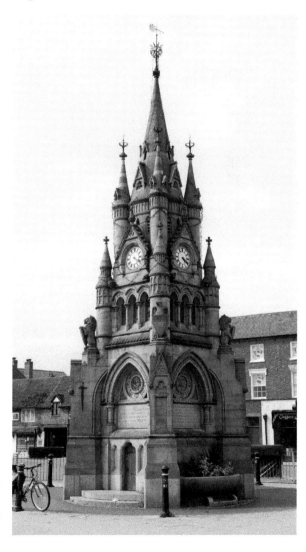

The American Fountain in
Rother Market, designed by
Jethro Cossins and unveiled in
1887. The water troughs (now
redeployed as flower planters)
were embellished with suitable
Shakespearean quotations.

50. Gower Monument, Bridgefoot

Finally, in this group, is the notable monument to William Shakespeare, the work of the gentleman-sculptor Lord Ronald Gower. At least six years in the making, the effigy of the poet himself is set high on a pedestal surrounded at ground level by statues of Lady Macbeth, Hamlet, Prince Hal and Falstaff. Gower presented the completed work to the town in 1888, when on 10 October it was unveiled by Lady Hodgson, wife of the mayor, Sir Arthur Hodgson, with an address by Oscar Wilde. The site originally chosen for the monument was in the garden to the south of the theatre (No. 47), with Shakespeare looking downstream towards Holy Trinity Church. It was moved to its present site in 1933, when the surrounding figures were more generously spaced out, as part of the redesign of the Bancroft Gardens – Shakespeare now has his back to the theatre and looks instead in the direction of a multi-storey car park.

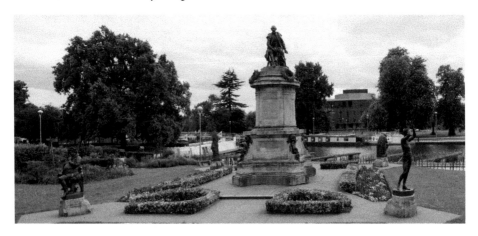

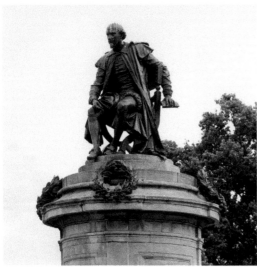

Above: Gower Monument, named after its designer, Lord Ronald Gower, at the northern end of the Bancroft Gardens, unveiled in 1888. It originally stood in the garden, south of the theatre (**No. 47**) with Shakespeare looking towards the church.

Left: Shakespeare sits in contemplation, now with his back to the theatre, following his removal in 1933 to his present location.

Acknowledgements and Further Reading

The authors would like to thank the editorial team at Amberley and the Collections team at the Shakespeare Birthplace Trust, particularly Paul Taylor and Amy Hurst, who in very difficult circumstances have supplied copies of historic images of some of our chosen buildings, and to the Trust, which has kindly agreed to their publication in this volume. We are also grateful to Andy Isham for the plan that appears on p. 9.

The following titles will allow the reader to explore further:

Bearman, Robert, *Stratford-upon-Avon: A History of Its Streets and Buildings* (Stratford-upon-Avon Society, 2nd edition, 2007)

Bearman, Robert (ed.), *The History of an English Borough: Stratford-upon-Avon 1196–1996* (Sutton Publishing: Stroud, 1997)

Edmondson, Paul, Kevin Colls and William Mitchell, *Finding New Place: An Archaeological Biography* (Manchester University Press: Manchester, 2016)

Fogg, Nicholas, *Stratford-upon-Avon: Portrait of a Town* (Phillimore: Chichester, 1986)

Morris, Richard K., *The Buildings of Stratford-upon-Avon* (Alan Sutton Publishing: Stroud, 1994)

Mulryne, J. R., *The Guild and Guild Buildings of Shakespeare's Stratford* (Ashgate: Farnham, 2012)

Pickford, Chris, and Nikolaus Pevsner, *The Buildings of England: Warwickshire* (Yale University Press: New Haven and London, 2016)

Pringle, Marian J., *The Theatres of Stratford-upon-Avon, 1785–1992* (Stratford-upon-Avon Society, 1993)

Styles, Philip, *The Borough of Stratford-upon-Avon and the Parish of Alveston* (London, 1946) reprinted from *The Victoria History of the County of Warwick: Volume 3* (London, 1945) pp. 221–88 (also available online at https://www-british-history-ac-uk.ezproxyd.bham.ac.uk/vch/warks/vol3)

About the Authors

Robert Bearman, MBE, BA (Oxon.), PhD (London), FRHistS, was formerly Head of Archives and Local Studies at the Shakespeare Birthplace Trust. He is the author of many published articles and papers relating to Stratford's history and other local history subjects, including *Stratford-upon-Avon: A History of Its Streets and Buildings*. He has also published widely on matters of Shakespearean biography, most recently in *Shakespeare's Money* (Oxford University Press, 2016).

Lindsay MacDonald, BSc, BEng (Sydney), PhD (UCL), FRPS, FBCS, is an Honorary Professor in the Faculty of Engineering Sciences at University College London. He is the author of 200 articles on colour image science in journals and conference proceedings, and the co-editor of ten books, including *Digital Heritage: Applying Digital Imaging to Cultural Heritage* (Elsevier: Oxford, 2006) plus *Exploring Shakespeare's Church* (IPN: Stratford 2021). He is Chairman of the Stratford Society.